Bakhtin Reframed

Contemporary Thinkers Reframed Series

Adorno Reframed ISBN: 978 1 84885 947 0
Geoff Boucher

Agamben Reframed ISBN: 978 1 78076 261 6
Dan Smith

Badiou Reframed ISBN: 978 1 78076 260 9
Alex Ling

Bakhtin Reframed ISBN: 978 1 78076 512 9
Deborah J. Haynes

Baudrillard Reframed ISBN: 978 1 84511 678 1
Kim Toffoletti

Deleuze Reframed ISBN: 978 1 84511 547 0
Damian Sutton & David Martin-Jones

Derrida Reframed ISBN: 978 1 84511 546 3
K. Malcolm Richards

Guattari Reframed ISBN: 978 1 78076 233 3
Paul Elliott

Heidegger Reframed ISBN: 978 1 84511 679 8
Barbara Bolt

Kristeva Reframed ISBN: 978 1 84511 660 6
Estelle Barrett

Lacan Reframed ISBN: 978 1 84511 548 7
Steven Z. Levine

Lyotard Reframed ISBN: 978 1 84511 680 4
Graham Jones

Merleau-Ponty Reframed ISBN: 978 1 84885 799 5
Andrew Fisher

Rancière Reframed ISBN: 978 1 78076 168 8
Toni Ross

Bakhtin

Reframed

Interpreting Key Thinkers for the Arts

Deborah J. Haynes

I.B. TAURIS

Published in 2013 by I.B.Tauris & Co. Ltd
6 Salem Road, London W2 4BU
175 Fifth Avenue, New York NY 10010
www.ibtauris.com

Distributed in the United States and Canada Exclusively by
Palgrave Macmillan 175 Fifth Avenue, New York NY 10010

ISBN: 978 1 78076 512 9

A full CIP record for this book is available from the British Library
A full CIP record for this book is available from the Library
of Congress

Library of Congress catalog card: available

Typeset in Egyptienne F by Dexter Haven Associates Ltd, London
Page design by Chris Bromley

Printed and bound by CPI Group (UK) Ltd, Croydon, CR0 4YY

Contents

List of illustrations

Acknowledgements

The ideas of Mikhail Bakhtin have lived in my consciousness for over twenty-five years. His thinking has shaped my understanding of every dimension of artistic creativity and the analysis of works of art. Thus I must first acknowledge that idiosyncratic Russian philosopher. I was introduced to Bakhtin's work at Harvard University by Dr Oleg Grabar (1929–2011), a brilliant and original scholar of Islamic cultures and a dedicated teacher. Dr Grabar encouraged me to explore the relevance of Bakhtin's ideas within art history. Art historian John House (1945–2012) died while I was completing this book, and I owe him a great debt for transforming my perception of Claude Monet's art. Among the Bakhtin scholars whose books and articles I have benefited from reading, I especially acknowledge Dr Caryl Emerson of Princeton University, whose sustained publications have shaped the entire field of Bakhtin studies and who has been formative in my deepening understanding of his opus and legacy. I dedicate *Bakhtin Reframed* to her.

I thank my colleagues at the University of Colorado Boulder, especially Albert Alhadeff, Kirk Ambrose, Mark Amerika, James Cordova, J.P. Park and Janet Robinson, who responded warmly to ideas in the book. Robert and Desirée Yarber of the Morris Graves Foundation gave me considerable feedback about Chapter 4. Margot Lovejoy continued our long dialogue about art and technology that began in the early 1990s. Karen Auvinen and Cyndy Brown offered substantial and valuable editorial assistance on the book as a whole. Gathering permissions for the reproductions

in the book entailed multiple communications with a number of individuals, and I am especially grateful to artist Amber Dawn Cobb (Denver), Marta Fodor (Museum of Fine Arts, Boston), Liz Kurtulik (Art Resource, New York), Margot Lovejoy (New York), Michael Plunkett (Metro Pictures, New York) and Pia Simig (Little Sparta Trust, Dunsyre, Scotland). In relation to the publication of *Bakhtin Reframed,* I warmly thank the editorial and production staff at I.B.Tauris. Liza Thompson's original enthusiasm carried the book forward through all the stages of production.

This book builds on my previous publications and lectures about Bakhtin, especially *Bakhtin and the Visual Arts* (Cambridge, 1995). An earlier version of Chapter 5, on Claude Monet's paintings, appeared in 1998 in *Semiotic Inquiry* as 'Answers First, Questions Later'. My reflections about creativity are adapted from a forthcoming article in the *Oxford Handbook of Religion and the Arts* (Oxford and New York, 2013).

Introduction

I have vivid images of Mikhail Mikhailovich Bakhtin, part fact, part constructed fiction. In one he sits in bed, a small table across his lap. His wife, Elena Aleksandrovna, brings tea, which she places next to his cigarettes and writing materials that clutter the table. Groups of friends gather in the evenings for long conversations. Given his intellectual acumen, these are simple pleasures. He writes, reflecting about what is, what could be, and what should be. I imagine that his aspiration as a young man to write a convincing moral philosophy was thwarted or at least displaced by other literary concerns and political exigencies of post-revolutionary Russia. But by curious twists of fate I find myself, a philosopher of art and artist, engaged in a sometimes-contentious dialogue with that young Mikhail Mikhailovich. My own questions about what could be and what should be are not fully answered, but they are affirmed and refined through this inner dialogue. Then I imagine an old man, still intellectually active, still exploring new ideas and concepts, still smoking and spending long hours with members of the Bakhtin Circle. To me the fact that throughout his long life Bakhtin could successfully write prosaic philosophy – a philosophy that privileges the pragmatic moral and ethical concerns of everyday existence – is one of the marks of its significance today, in the early decades of the twenty-first century.

Bakhtin was born in 1895 in Oryol, Russia, and grew up in Vilnius, a Lithuanian town called 'the Jerusalem of the North'

because of its rich Jewish intellectual heritage, and in Odessa. He studied philology and classics at Petrograd University between 1914 and 1918, and later lived in small Russian cities such as Nevel, Vitebsk, Kustanai, Saransk and Savelovo, as well as Leningrad and Moscow. Bakhtin's years in Nevel and Vitebsk overlapped with the period in which artists Marc Chagall and Kasimir Malevich worked there, although it appears that he did not know them. Bakhtin was active in both literary and philosophical circles for most of his life, but in the mid-1920s he contracted osteomyelitis, a disease that limited his mobility. During Stalinist periods of harsh repression, Bakhtin and his wife were exiled from Moscow. He taught high school and briefly at a teacher's college in Mordovia, and later worked as a bookkeeper in the Siberian hinterlands. Bakhtin was eighty years old when he died in 1975; only since his death have his ideas become widely known throughout the world. These few biographical details barely provide a context for the historical and cultural events of the early twentieth century when Bakhtin began writing. Consequently, I shall have more to say later in the book about both his personal life and the context for his work.

Since Bakhtin's writings began to appear in print consistently during the 1960s, his name has often been associated with concepts such as carnival, developed in *Rabelais and His World* (1984b), and dialogue or dialogism, developed in *The Dialogical Imagination*. But concentration on the carnivalesque or the dialogic has tended to skew the adaptation of Bakhtin's work by scholars in many disciplines. The areas in which scholars have fruitfully engaged his ideas include communication and media studies, composition, cultural studies, education and educational theory, ethics, film and television, law and critical legal studies, linguistics and philosophy of language, literature, medicine and studies on aging, multicultural and cross-cultural studies, philosophy, political theory, psychology and psychoanalysis, religion, sociology, theatre and performance, and urban studies.

Curiously, artists, art historians, art theorists and critics have been slow to adapt Bakhtin's concepts to analyses of visual culture and to visual art practice. The purpose of this volume, therefore, is to create an accessible introduction to his work, a bridge between the sometimes-abstruse musings of a twentieth-century Russian philosopher and twenty-first-century artists and scholars. On the one hand, the unique language developed by Bakhtin – from his earliest published essays in the 1920s to his last notes in the early 1970s – contributes greatly to both philosophical and pragmatic categories in the arts. Ideas such as answerability, outsideness, unfinalisability, dialogue, monologism, polyphony, heteroglossia, chronotope and the carnivalesque, to name but a few, are powerful concepts for redefining philosophical aesthetics and theories of creativity. On the other hand, these and other ideas offer contemporary artists, critics and scholars of the arts practical ways of analysing genre, the emergence of new narrative structures, and new forms in contemporary art, as well as new ways of interpreting creative studio practice. Bakhtin's work can also aid critics and historians in creating taxonomies for interpreting works of verbal and visual art in relation to one another. His writing predates and anticipates a variety of ideas within literary and cultural movements such as neohistoricism, poststructuralism and postmodernism.

Whether interpreting visual culture in general, media images, film and the Internet, high art or popular art, Bakhtin's ideas generate significant new insights. This volume offers an overview of his understanding of aesthetics and the creative process. It is further organised around issues related to the work of art; the artist as creator; and the context, reception and audience for the work of art in the wider world. Specific concepts that are useful for both the practice and interpretation of visual art are interwoven throughout the chapters. There is thus a recursive nature to my discussions of particular ideas as I explore their relevance to the main themes that organise the book. Each chapter opens with an

'epi-eikon', an image of a work of art that provides a frame of reference for the content of that chapter. These epi-eikons include artwork from diverse cultures between the eighteenth and twenty-first centuries, created by both anonymous and well-known artists. Some chapters are focused on understanding Bakhtin's ideas through examining existing art, while others are directed toward the challenges faced by working artists in the studio.

Chapter 1 examines Bakhtin's aesthetics in general terms, and it is the most technical part of *Bakhtin Reframed*. Commencing with an eighteenth- or nineteenth-century carved *atal* stone from the Cross River region of modern Nigeria, this chapter raises the question of 'whose aesthetics' we study. Aesthetic theory can describe what happens when we look. Such a theory of looking is not just phenomenological but, as Bakhtin's writing shows, it must also describe a genuine encounter of one consciousness with another. The goal of aesthetic experience and of creative art should be to see another life for its significance qua life. But aesthetic theory can also move toward what Bakhtin called 'theoretism'. One of the most significant contributions of Bakhtin's aesthetics to contemporary art is his affirmation that art must exist in an integral relationship with life, that art for its own sake is mere artifice.

Chapter 2 considers the question of what creativity is in practice. This chapter opens with M.C. Richards's *Dream Angel*, a small sculpture that subtly articulates questions that Bakhtin may not have answered but that we should consider. Here I discuss creative cycles in Bakhtin's life, definitions and paradoxes in our understanding of creativity, and the philosophical roots of his views in Greek and European philosophical traditions. Three ideas from Bakhtin's writing of the 1920s – answerability, outsideness, and the degree of finalisability or unfinalisability of a creative act – are a meditation on the crucial links between creativity and religious and moral issues. Bakhtin's ideas offer renewed appreciation for the world-forming potential of the artist's creative vision and creative voice.

Chapter 3 turns to the artist, and especially to the relationship of the self and the other as Bakhtin defined that unique relationship. An image of Marina Abramović's 2010 performance *The Artist Is Present* opens this chapter. Any discussion of the usefulness of Bakhtin's ideas must begin with a brief description of his understanding of the phenomenology of the self and self–other relationships, which he articulated with the concepts of answerability and the dialogic. I also discuss how his concept of outsideness can be usefully extended in terms of 'difference', which is so well conveyed in feminist theory. Unlike some of his contemporaries such as Maurice Merleau-Ponty and Henri Bergson, Bakhtin's goal was not to create a moral or philosophical system. Most of his essays are predicated on the presupposition that the human being is the centre around which all action in the real world, including art, is organised. In his writing, the 'I' and the 'other' are the fundamental categories of value that make all action and creativity possible, as in the work of Martin Buber and Emmanuel Levinas.

Chapter 4 reflects on the work of art itself. What constitutes a 'work of art'? Ian Hamilton Finlay's lifelong engagement at *Little Sparta*, a site near Edinburgh, Scotland, provides the epi-eikon for this chapter. Later I compare it to a little-known site in California, Morris Graves's *The Lake*, and raise the question of what Bakhtin's ideas add to the interpretive repertoire of artists and scholars who work in the arenas of new genres and visual culture studies. To this end I examine the relevance of three major concepts in Bakhtin's oeuvre: the chronotope, prosaics and genre, including the application of his theories of the novel to the visual arts. Several provocative reflections about time, emergence or becoming, and the magicality of language aid in further developing my interpretation of works of art. Here in particular I explore how the work of art is interdependent within historical structures and cultural processes: it never exists autonomously, but is conditioned by traditions and ideologies at

every level. This starting point is the foundation of Bakhtin's view as well.

Chapter 5 offers an integrated Bakhtinian interpretation of the art of Claude Monet during a particular period of the artist's life, from 1884 to 1908, when Monet made three journeys to paint at sites around the Mediterranean. Monet's 1884 *Cap Martin, near Menton* and his 1908 *Grand Canal* provide primary points of reference for my analysis of his work in this chapter. Here I seek to demonstrate how several of Bakhtin's major concepts – answerability, dialogue, outsideness, chronotope and unfinalisability – are specifically useful within an art historical context.

Chapter 6 analyses the nature of the audience and reception of the work of art within its wider cultural context. This chapter opens with an image from *Turns*, an online work by Margot Lovejoy, who was an early proponent of digital art. An extended discussion of Bakhtin's historical context follows, with further reflection about the reception of his ideas. Then, using Lovejoy's work as well as other examples of digital art, I discuss the need for 'ethical aesthetics' in our contemporary context. The chapter ends with consideration of one of the most crucial questions artists must address in their studio practice: 'Who is my audience?' The answer to this complex question is governed by many factors related to values, historical moment, time and place, even fate. Bakhtin did not address such questions directly, but his essays and books teach us to reflect about the interrelationship of ethics and aesthetics.

The short conclusion summarises my claim that Bakhtin's ideas offer contemporary artists and scholars generative categories for their creative work and scholarly endeavours. Bakhtin frequently coined terms that are challenging to translate, and the glossary proffers working definitions of terms that are relevant to this book. The selected bibliography provides additional resources that will be helpful to the interested reader.

Over several decades scholars have described Bakhtin as a moral philosopher, a literary analyst and an eclectic prosaic

thinker. *Bakhtin Reframed* examines his work as a sustained aesthetic theory that has implications for how contemporary artists create and for how art historians interpret both historical and contemporary art. Ideas live in many spheres: on the pages of books, in the intellect and imagination, and as the spur and/or corrective for action in life. Earlier I used the image of this book as a bridge between the philosophical reflections of a twentieth-century Russian philosopher and twenty-first-century readers, and bridge building is part of the larger dialogue of cultures that fascinated Bakhtin until the end of his life.

The beginning three-minute montage of Woody Allen's 2011 film *Midnight in Paris* opens with a daytime shot of the Eiffel Tower and the single-span Pont Alexandre III in the foreground. To my viewer's eye, bridges serve as a powerful metaphor in Allen's film, with multiple images of the Pont Neuf, Pont Alexandre III and other bridges that cross the Seine. At the film's conclusion, the main protagonist Gil Pender meanders across the elegant and ornate Pont Alexandre III. This time the Eiffel Tower and Pont Neuf shimmer in the background. Just prior to this moment, he has told his 1920s paramour Adriana that he does not want to stay in her era or the Belle Époque. Gil acknowledges that the present is unsatisfying, just as life itself can be unsatisfying. Writing, for him, now involves getting rid of his illusions, especially the illusion that he would be happier in the past. Gil runs into Gabrielle, an antique dealer whom he had met earlier. Gil tells her that he has decided to move to Paris in order to write. The film ends as these two declare their shared love of walking in the rain and set off across the bridge.

Clearly the present is a messy place, and real life seldom replicates tidy film endings. But the present is where we live and should live if we are to reap the riches of this precious human life. I hope that *Bakhtin Reframed* provides a bridge from the past into the present, and that it will help to generate new insights for future creative and scholarly work.

Chapter 1

Bakhtinian aesthetics

I did not grow up near major national or international museums; my love of museums began during my first solitary trip to New York City as a young adult. Years later I lived close to the Museum of Fine Arts (MFA) in Boston, Massachusetts, and I would often stop by to see the latest exhibitions and visit a favourite gallery or a particular work of art. During one of my infrequent visits to the MFA after moving across the country, I was strolling through newly installed galleries of African art. Suddenly I was riveted by a basalt sculpture with a distinctly human face (Figure 1). I stopped and stared at it, and the stone seemed to stare back. I made multiple drawings in my journal, which inspired subsequent art of my own. This experience was one of a few such life-changing events that involved looking at art.[1]

This particular stone monolith has an overall ovoid shape, with a face carved in low relief on its front. The face consists of a long nose, deeply incised round mouth and small eyes with multiple brow lines. Cuts into the face appeared to be tears when I first scrutinised it, but probably allude to facial tattoos, painting or scarification. The face is framed by raised lines and has a smooth, domed top. Spirals and angular lines are carved below. This stone, called *atal* or *akwanshi*, was carved between the eighteenth and nineteenth centuries, and comes from the Cross River region of Central Africa. Made of basalt, it is approximately 29 inches tall. Although sculpture made of such hard stone is rare in sub-Saharan Africa, about 300 similar works have been

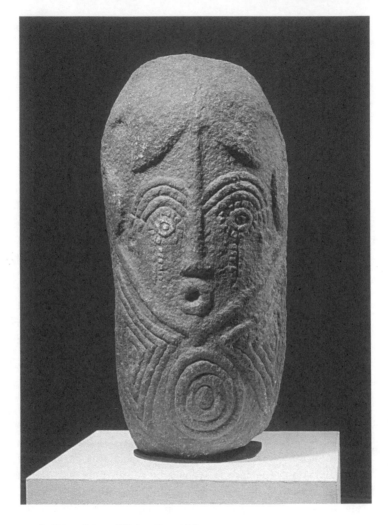

1. *Carved stone (Atal or Akwanshi)*,
Nigeria, eighteenth–nineteenth century,
Photograph © 2012 Museum of Fine
Arts, Boston.

documented from the forested region of the mid-Cross River in Nigeria. The Ejagham peoples who live in this region call them *akwanshi* (dead person in the ground); neighbouring groups refer to these monoliths as *atal* (the stone). Perhaps intended to memorialise the dead, *atal* were carved from volcanic boulders by grinding or pecking with stone or metal tools to create a human face and simplified body.

These stones are deemed significant enough to be mentioned in textbooks and they attract attention among tourists, but it is hard to find reliable information about why and how they were created. As Philip Allison described in one of the only extant publications on these stones, it has been difficult to collect any coherent oral knowledge about their history. Traditions related to the stones remain vague, and the stones are generally described by residents of the area as having been carved 'a very long time ago by the forefathers of the present occupiers of the land and to commemorate the ancestors of the tribe or village' (1968: 35). Further difficulty tracing their history is related to the fact that many *atal* have been moved from their original locations, broken and 'repurposed' – used in more recent building construction. However, the most pertinent point is my encounter with the MFA *atal*, not the anthropological and art historical details that have been lost.

In this chapter I explore Bakhtin's aesthetics in order to provide a philosophical grounding for the book. Of particular focus are his ideas regarding 'art for life's sake' and 'theoretism'; I consider both of these concepts foundational to his oeuvre. While my discussion of aesthetics as a form of theoretism is technical, it is intended to offer a summary of Bakhtin's philosophical interests. Yet here, at the beginning of the chapter, I also want to raise complex questions about whose aesthetics we rely on and use. The tradition of placing *atal* in the ground evolved in Central Africa among communities with no access to these European traditions. Are the aesthetic categories derived from European philosophy and art history adequate for engaging and understanding the art

of cultures outside the European West? If so, how are they useful and what are their limitations? If not, how can one gain a thorough grounding in cultural theories that may be unfamiliar? I will return to these questions at the end of the chapter after discussing African aesthetics. I believe it is imperative for both art historians and artists to familiarise ourselves with art outside of the Western canon, and to ask if and how the theories we use are relevant in other contexts.

Art for life's sake

More than two decades ago I was drawn to Bakhtin's writing when I read 'Art and Answerability' in Russian, an essay he wrote in 1919. I laboured over the translation of various words, and my curiosity was piqued. I had been interested in the religious and moral overtones of the nineteenth-century debate about art for art's sake versus art for life's sake. In his short two-page essay, written at the young age of 24, Bakhtin clearly located himself in the art for life's sake camp, and I recognised him immediately as a kindred spirit. Art and life, he stated, should answer each other. Without recognition of life, art would be mere artifice; without the energy of art, life would be impoverished. One of the most significant points of connection between art and life is the human act or deed. Even if we do not know the artist's name, a work of art such as the *atal* is an example of the artist's action in the world. Carved and placed in a forest setting, the *atal* expresses both individual creativity and community values – precisely the intersection of art and life that Bakhtin valued.

Philosophically based in the writings of Kant, Schiller, Goethe, Schelling and Friedrich Schlegel, the idea of art for art's sake had adherents in France, England and Germany, especially during the nineteenth century.[2] Among its primary tenets were the following interrelated ideas. First, art has its own distinctive sphere in which the artist is sovereign. Second, the artist's freedom is essential because the artist should be committed only to personal vision and

not to his or her culture, school or a given formal structure. Third, the so-called 'true' artist is concerned only with aesthetic perfection and not with the personal or social effects of the work of art. In other words, the highest goal of life should be aesthetic creation rather than moral development or religious values. Fourth, aesthetic perfection is achieved through the expression of form, where 'expression' is understood to mean that an artist expresses inner vision rather than outer appearance. Fifth, creative imagination should predominate over cognitive or affective processes of thought and reflection. These ideas were expressed in literature and the visual arts in a variety of ways, but for Bakhtin art for art's sake constituted a fundamental crisis, an attempt by writers and artists simply to try to surpass the art of the past without considering their own moral responsibility. In contrast, Bakhtin followed nineteenth-century aestheticians such as Jean-Marie Guyau, who were convinced that art must be deeply connected to life (1947).

At its foundation, Bakhtinian aesthetics is profoundly moral and religious. In fact, Bakhtin's early aesthetic essays derived many of their terms from theology (Pechey 2007: 153). For example, in notes taken by L.V. Pumpiansky during Bakhtin's lectures of 1924–25, Bakhtin reputedly said that aesthetics is similar to religion inasmuch as both help to transfigure life (2001: 207–8). He discussed how 'grounded peace' is foundational for both religious experience and aesthetic activity. Grounded peace is an odd term, but it is used here to mean a state of rest, tranquility and peace of mind. This interpenetration of the religious and aesthetic is further expressed throughout Bakhtin's writing with themes such as love, grace, the urge toward confession, responsive conscience, reverence, silence, freedom from fear and a sense of plenitude. Yet even if Bakhtin's political and cultural context had allowed it, he would not have been inclined to 'preach a religious platform', as Caryl Emerson so astutely observed (in Felch and Contino 2001: 177). He was, by temperament, neither didactic nor proselytising.

Theories and theoretism

Mikhail Bakhtin's understanding of European philosophical aesthetics evolved in relation to his historical situation, which I will discuss in greater detail in Chapter 6. But interpretations of historical processes and events are not the only part of his context. His early essays and later books and essays are filled with both tacit and overt philosophical references, many of which are obscure for the contemporary reader. Many statements remain incomprehensible unless interpreted in relation to Bakhtin's partners in intellectual conversation, especially Kantian and Neo-Kantian philosophers.

Since the 1730s when Alexander Baumgarten coined the term, 'aesthetics' has remained ambiguous. For Baumgarten and for Kant, who expanded on his ideas, aesthetics had to do with sensory knowledge or sensory cognition, which included but was not limited to the problem of beauty. In a broad sense Bakhtin's understanding of aesthetics fits into such a definition. He was concerned with how humans give form to their experience – how we perceive an object, text or another person, and how we shape that perception into a synthesised whole. But rather than focusing on beauty as in traditional aesthetics, Bakhtin developed a unique vocabulary for describing the process by which we literally 'author' one another, as well as artifacts such as works of art and literary texts, with concepts that I discuss in detail in the next chapter.

Bakhtin actively refuted Kantian aesthetics from two directions. First he challenged 'impressive' theorists such as Konrad Fiedler, Adolf Hildebrand, Eduard Hanslick and Alois Riegl, who, in his view, centred too heavily on the creating consciousness and the artist's interaction with the material. In his essay 'Artist and Hero in Aesthetic Activity', Bakhtin twice mentions Riegl as one of those historians for whom 'the artist's act of creation is conceived as a one-sided act confronted not by another *subiectum* [subject], but only by an object, only by material to be worked. Form is deduced from the peculiarities

of the material – visual, auditory, etc.' (1990: 92). Because Riegl was a European art historian whose influence helped to shape the modern discipline of art history, a brief discussion of his ideas is relevant here. Had he known more about Riegl, Bakhtin might have viewed him as a congenial thinker.

Riegl attacked many traditional art historical methods, including factual history, iconographical study that stressed subject matter, biographical criticism that focused on the artist, mechanistic explanations of style, aesthetics severed from history and hierarchical distinctions between the arts (Zerner 1976: 179). That Bakhtin would have challenged Riegl's ideas is understandable, especially given Riegl's articulation of the importance of *Kunstwollen*, variously translated as 'artistic intention', 'formative will' or 'stylistic intent'. With the concept of *Kunstwollen*, Riegl was searching for an adequate way to describe the continuous development of visual form – that is, how styles are transformed from culture to culture and from one historical period to the next. Riegl insisted that all stages and expressions of art are of equal value, though the artist's intention would be expressed in different ways. Therefore he considered judgements about both progress and decline to be problematic. In contrast to the mechanistic models of other art historians, Riegl interpreted artistic creativity in a much more complex way, emphasising a view of the artist as an individual seeking to resolve unique artistic problems (Pächt 1963: 191). Nevertheless, he tended to negate the importance of the individual in favour of larger creative forces in history. In this he followed the trend of late nineteenth-century thought, which valorised evolutionary ideas over individual innovation (Holly 1984: 78–79). Yet Riegl's formalism was modified by his interest in the acting agent, the creator in artistic activity. Bakhtin's criticism that Riegl looked only at the object and material seems too reductionist. Although Riegl did not use the language of consciousness, self and other that Bakhtin preferred, he certainly did attempt

to think inclusively about the relationship of artist, artwork and context.

Bakhtin's second challenge to modern aesthetic theories turned in another direction. In addition to criticising impressive aesthetics, he was convinced that 'expressive' theories were limited because they were based on the idea that art is primarily an expression of feelings and the inner self. Taking the human being as the primary subject and object of inquiry, expressive aesthetics is decidedly anthropocentric. Everything, even line and colour, is given human attributes. Within expressive aesthetics the goal of aesthetic perception and the aesthetic act is to empathise and to experience the object as if from within, such that the contemplator and the object literally coincide. There is no juxtaposition of an 'I' and an 'other', which in Bakhtin's view was essential to the aesthetic process.

His critique of expressive aesthetics was based on three main points. First, empathy occurs in all aspects of life, not just in aesthetic experience. How might my empathetic response to the tears I perceived on the face of the *atal* be different from my empathetic response to my friend's divorce? 'Expressive' philosophers such as Theodor Lipps and Hermann Cohen do not describe how aesthetic coexperiencing and empathy differ from empathy more generally; consequently, Bakhtin believed their theories had limited applicability. Second, expressive aesthetics cannot adequately account for the entirety of a work of art because it focuses on the artist's or viewer's feelings. What of the geographical context that determines available materials, or the political context that informs a work of art? Expressive aesthetics would not get us very far in interpreting the *atal*. Third, it cannot provide the basis for understanding and interpreting form because it fails to see the complex processes through which particular cultural and individual forms evolve. Bakhtin placed a diverse group of philosophers – Lipps, Cohen, Robert Vischer, Johannes Volkelt, Wilhelm Wundt, Karl Groos, Konrad Lange,

Arthur Schopenhauer and Henri Bergson – in this category of expressive aesthetics and tried to develop an alternative and more adequate approach.[3]

In contrast to both impressive and expressive theories, Bakhtin described aesthetic activity as a three-part process. The first moment is projecting the self: to experience, see and know what another person experiences by putting oneself in the other's place. This moment is similar to the Neo-Kantian notion of empathy. My own immediate response to the *atal* in its MFA setting – feelings of compassion and curiosity about the 'tears' that I perceived – was understandable, especially given that a beloved friend was very ill and dying at that time. Bakhtin's second moment of aesthetic activity properly begins only when one returns to one's singular place, outside of the other person or object. This occurred for me when I began to seek more information about the cultural and artistic traditions of the *atal*, and a few months later initiated a marble sculpture that was inspired by the *atal*'s form.

The third moment is less relevant to my experience of the *atal*. In Bakhtin's model, the viewer can 'fill in' the other's horizon, 'enframe him, create a consummating, that is finalising, environment for him out of this surplus of my own seeing, knowing, desiring, and feeling' (1990: 25). In this statement Bakhtin seems to say that all power resides in the self. Such power to 'enframe' is dangerously close to the power to control and imprison. Certainly, with his benign view of the universe, imprisonment would have been far from Bakhtin's mind, but the implications of such language cannot escape the notice of a twenty-first-century reader. The importance of his model is that Bakhtin brings us back to the aesthetics of the creative process itself – back to the activity of the artist who creates.

Still, Bakhtin never explicitly defined aesthetics. Unlike both Kantians and Neo-Kantians, Bakhtin shunned orderly systematic thought, preferring instead to muse and work out ideas by following the circuitous and often fragmentary meanderings of imagination.

His early essays, especially 'The Problem of Content, Material, and Form in Verbal Art', contain his most sustained treatment of philosophical aesthetics (Bakhtin 1990). Following Kant, Bakhtin treated the aesthetic as a sphere in which reason and ethics could be brought together, but he pressed further than Kant and Neo-Kantians such as Hermann Cohen in defining their activity. According to Bakhtin, each of these three spheres (reason or rational cognition, ethical action and aesthetic practice) describes reality differently. By assuming primacy, reason tends to be falsely separated from ethics and aesthetics. Unavoidably, even while trying to establish its own uniqueness, reason reflects ethical and aesthetic judgements. The realm of ethical action differs from the cognitive because here one encounters conflict over moral duty or obligation, but ethics cannot really be separated from cognitive functioning. Consequently, Bakhtin concluded that neither reason nor ethics alone could provide a foundation for philosophy.

Bakhtin did not think that aesthetic activity could create a completely new reality. Rather, he wrote, 'Art celebrates, adorns, and recollects...It enriches and completes them [rationality and ethics], and above all else it creates the concrete intuitive unity of these two worlds.' For him aesthetic activity places the human being in nature, thereby humanising nature and naturalising the person (Bakhtin 1990: 278–79). This statement articulates why Bakhtin focused on the aesthetic dimension of life. By unifying nature and humanity with cognition and action, he hypothesised that aesthetics could become the basis for a new approach to philosophy. The uniqueness of Bakhtin's approach to aesthetics is that it is based not on traditional aesthetic values such as truth, goodness or beauty, but on the phenomenology of self–other relations, relations that are embodied – in actual bodies – in space and in time.

In his essays Bakhtin addressed traditional aesthetic categories such as detachment, empathy, isolation and the aesthetic object, as well as theories of art and the relationship of art and morality.

But his discussions of all of these categories and topics were grounded in the unique human being, located spatially and temporally, and thus having a particular relationship to all other persons, objects and events in the world. As humans struggle to express and to shape perception and experience, they engage in creative aesthetic activity. Bakhtin called such activity 'authoring'. His interpretation of authorship was not limited to literary texts; he viewed authoring as a process involving other persons, nature and works of art. In Bakhtin's vocabulary, to author is to create. Just as Bakhtin avoided clear definitions of aesthetics and creativity, he never produced a systematic theory of what this might mean in terms of the creative process.

Bakhtin used the term 'theoretism' to describe his aversion to all such unified and orderly structures or systems, but like his writing on other topics, Bakhtin's critique of theoretism was neither sustained nor systematic. He developed this critique early in his intellectual life. In *Toward a Philosophy of the Act*, he wrote:

> Any kind of practical orientation of my life within the theoretical world is impossible, it is impossible to live in it, impossible to perform answerable deeds. In that world I am unnecessary; I am essentially and fundamentally non-existent in it. The theoretical world is obtained through an essential and fundamental abstraction from the fact of my unique being. (1993: 9)

In this statement Bakhtin made two interrelated assertions. On the one hand, he was convinced that theory cannot provide the basis for responsible action in the world because it does not translate directly into everyday life and experience. Too often, immersion in the theoretical takes place at the expense of the everyday, the practical. On the other hand, our specific acts or deeds do provide a basis for assessing what is most meaningful and for creating an adequate orientation in life. Nevertheless, his resistance to all forms of theoretism did not preclude writing theoretical texts that are difficult to unpack.

Bakhtin's view of theoretism may be best understood as a multistep process and way of thinking. First, it abstracts what can be generalised from specific human actions. Second, it considers that abstraction to be whole and complete; then, third, theoretism develops a set of rules from the abstraction. Fourth, norms are derived from this set of rules. As Gary Saul Morson and Caryl Emerson summarise Bakhtin's view, 'Faith in rules, norms, theories, and systems blinds us to the particular person and situation, which is where morality resides' (1989: 9). By abstracting rules, norms or theories from actual human actions and mistaking those theories for the truth, the philosopher or artist loses connection to the unique human being and to real moral engagement. Bakhtin avoided systematic and practical analyses of individual texts and authors, which might have demonstrated clearly what the implications of this model actually are in practice. He was ultimately more concerned with poetics or what Morson and Emerson have named 'prosaics', the messiness of everyday life (1990).

Among diverse contemporary theories, feminism is a prosaic philosophy that provides a powerful contemporary reference point for understanding Bakhtin's resistance to theory. Both Bakhtin's writing and feminist theory demonstrate that theories can be used to understand systems (including the philosophical constructs) that affect our lives. In this sense theory is not a totalising but rather a partial and fragmentary process.[4] Theory is an especially useful ally in political struggles because of its empowering effects. Theory and practice are inextricable: practice can be seen as a set of relays from one theoretical point to another. Theories encounter walls, which practice helps one climb over. Theories are neither an expression nor translation of practice; they can also be forms of practice. Theory may be likened to a box of tools from which we take what we need. This concept is especially congenial for artists, who use a wide variety of tools for creative work.

But what does it really mean to suggest that theory is like a box of tools? As part of her criticism of theory, Luce Irigaray points out that the 'tool' is not a feminine category since women do not have tools (1985: 150). Or, in Audre Lorde's words, 'the master's tools will never dismantle the master's house' (1984: 112). I continue to question these controversial statements. What do we have if not tools? We have our perceptions, intuitions, minds and bodies, as well as material artifacts such as paintbrushes, angle grinders and laptop computers. How do we use them? How do we exercise power with the aid of our 'selves'? How is the self itself constructed? Although I cannot answer these questions adequately here, I believe that theory, as one of the primary tools of radical thought during the past decades, has helped to expose the hidden agendas and the gender biases of our language, cultural institutions and art-making processes.

One thing is clear: theory is never neutral. It is also an instrument of power most often wielded by those who have power. Most influential theories have been created by men. The extensive debate about modernisms and postmodernisms in which feminist theorists participated in the late twentieth century is part of the 'race for theory', to use Barbara Christian's phrase (1988). I am aware that all writers necessarily build on the ideas, theories and images of others. This is certainly true of my own thinking and writing. What I would criticise are the particular pretences and forms of much theorising. I am not against theorising as such, as should be evident from the shape of this chapter and of *Bakhtin Reframed* more generally. However, theory and practice must interact and mutually transform each other.

Another pressing question arises at this point. How is it possible to use our theories to transform ourselves, our relationships and our social institutions while we and our theories are still changing? In this situation we may need to embrace the

very instability of analytical categories, using that instability to reflect on our political realities. Such instabilities may then be a resource for our thinking and our action (Harding 1989: 18). As theories change, the process of deconstructing dominant theories of the past must also continue in order to suspend any pretence that we are producing truth and univocal meaning. Challenging philosophical discourse is useful because it is the discourse on discourse, the theory of theories. We may go back to it to try to find out what accounts for its power and its position of mastery. We do not have to give ourselves over to a symbolic, point-by-point interpretation of philosophers' ideas, but instead examine the way grammar and syntax, the metaphors and silences, operate in a particular discourse (Irigaray 1985: 75–79). As Bakhtin seemed to understand, our own methods and theories for this deconstructive process may elude systematic definition.

I suggest that artists will find it useful to study aesthetic theory and theories of art history that have helped to define so many categories within the arts. Artists may also be creatively engaged by trying to understand how social or aesthetic theories can aid them in developing and interpreting their own work. For example, artist Amber Dawn Cobb devoted tremendous energy and time to studying Julia Kristeva's difficult concept of the 'abject'. Over the course of a year, this study helped her to find both a verbal language and new ways of giving form in her art to powerful formative experiences of childhood abuse and addiction. Her 'cognitive maps' (Figure 2) are exemplary explorations of how to link what she was learning with her creative process. The installations that emerged were challenging to look at and, for some viewers, enigmatic and impossible to unpack.[5] For me, they were profoundly moving.

This example demonstrates Cobb's constructive commitment to making theory relevant. For many artists, as well as for scholars and critics, theories must be especially attentive to individual and cultural difference, to the uniqueness, particularity or specificity

of both the theorist and that which is theorised. Further, theory should be united with pragmatic strategies for action in the world. Thus, to paraphrase writer bell hooks, the broad purpose of studying and understanding theory is to provide a structure of analysis that synthesises what is most visionary in contemporary discourse with strategies of resistance that aid us in our struggles for personal, social and artistic liberation (1989: 35). In order to do this, I believe that theory should be written and presented in ways that are accessible to all, including artists and those without privileged educations. There is certainly a place for theory that uses convoluted technical language, yet only if it is accessible can such theory become the groundwork for creative work and, in the future, for social change.

To conclude this excursus on theory and theoretism, I emphasise again that Bakhtin identified all theories isolated from action as the enemy. Bakhtin was adamant about the

2. Amber Dawn Cobb, *Cognitive Map* (2011).

limitations of theory. Theories cannot help us to gain practical orientation in life when developed in the abstract, as if the unique individual in particular situations did not exist. This abstract quality means that theories cannot provide criteria that would shape one's life of action and practice (Bakhtin 1993: 9). Nonetheless, Bakhtin's resistance to theory did not preclude his writing theoretical texts. In many of his essays he may have avoided systematic and practical analyses of individual texts and authors, but he articulated the basis of his aesthetics and his notion of creativity.

Considering African aesthetics

Where do these reflections leave us regarding the *atal* that opened this chapter? I would strongly suggest that the ideas I have just been exploring about theory and practice are only partially applicable to the arts that emerge from cultures not connected to European philosophical or aesthetic traditions. As far as we know, the individuals who carved 300 *atal* and placed them in Central African forests were concerned neither with aesthetic theories derived from European philosophy, nor with debates about whether their aesthetic practice was a form of art for art's sake or art for life's sake.

In the late nineteenth century such works would have fallen into the category of 'primitivism', a term used by Western art historians to characterise indigenous art of the Pacific, Africa and the Americas that was created by anonymous artists. Paul Gauguin's fascination with the arts of the Pacific, especially in Tahiti and the Marquesas; Pablo Picasso's embrace of African arts in the early twentieth century; and Jackson Pollock's attraction to Navajo sand painting in the early 1940s are all examples of artists who became interested in what was then called 'primitive' art. Each of these artists, and many others, appropriated visual strategies from these cultures for their own ends. The word 'primitive' actually means 'early' or 'first of its kind', but the

word was used pejoratively to imply crude, simple and backward cultures. This concept has been widely challenged within each of the unique cultures I mentioned. In particular, by showing that African artists used high-quality and advanced technologies for their times, that African people have recorded their history since at least the tenth century, and that they built great cities of culture, the myth of the primitive has been overturned (Visona 2008: 19–23).

African arts such as the *atal* also raise the fascinating issue of an artist's anonymity. In other cultures of the world such as Tibet and medieval Russia, artists were encouraged to create paintings and sculptures without signing their names. This practice was part of a larger spiritual discipline that involved undermining the artist's attachment to the ego and personal self. There were exceptions, of course, but anonymity was considered part of the spiritual framework of these traditions. In contrast, the greatest artists in African Yoruban cultures were famous and sought-after individuals, though we do not know many of their names. Artists rarely revealed their full given names to strangers, much as a contemporary US citizen would not give a PIN number or social security number to a stranger (Visona 2008: 11–12). We do not know who created the particular *atal* that opens this chapter, but this does not mean that the artist or artists were unknown in their own context.

The discovery of a three-inch, carved, ochre plaque in the Blombos Cave in southern Africa dating from 70,000 BCE demonstrates that artists on the African continent have long created diverse traditions of art. They have incorporated approaches from naturalism to abstraction, using media ranging from sculpture, textiles and architecture, to ritual masquerade, performance and body decoration. Art historians have often held the false assumption that they could understand and interpret diverse African cultures and art using Western European values and standards, but scholars of the arts of the

African continent promote several categories that have been developed from a less-Eurocentric point of view. Over centuries, African artists in many media have made formal innovations, given primacy to sculptural forms that emphasise humanism and anthropomorphism, developed new forms of visual abstraction and, especially, created parallel asymmetries in artistic forms such as architecture. The curators of the 2010–11 exhibition *Global Africa* described the work of diverse contemporary artists from the African continent and African diaspora as sharing several characteristics, including a focus on surface and pattern; the use of unexpected materials, including items that are recycled or repurposed; and the intersection of traditional techniques and forms with contemporary design (Sims and King-Hammond 2010: 13).

Several of these aesthetic qualities can be seen in the *atal* from the Boston MFA. From the most general perspective, this *atal* reflects the primacy of the sculptural that scholars have identified as characteristic of the arts of the African continent. The form of the sculpture reveals the maker's effort to shape and anthropomorphise the raw stone, which would not have been so evenly cylindrical. Unlike other *atal* and *akwanshi* where artists incorporated given irregular forms of the stone, the MFA *atal* was symmetrically shaped to create a human face and body. It also demonstrates the artist's attention to the stone's surface and pattern. The patterns of the face, which I found so riveting when I first viewed it, could only have been made through exceedingly careful work with simple stone tools.

Bakhtin did not write about cross-cultural encounters with art. However, after he died in 1975 two collections of undated notes from the 1940s to the 1970s were published as part of *Speech Genres and Other Essays* (Bakhtin 1986). Bakhtin had kept handwritten notebooks for decades, reputedly using the pages to roll cigarettes during periods of poverty when paper was scarce. These notebooks contain fascinating and suggestive

fragments about cultural encounter and study. In them Bakhtin wrote about the study of culture as 'open, becoming, unresolved and unpredetermined, capable of death and renewal, transcending itself, that is, exceeding its own boundaries' (Bakhtin 1986: 135). What I have been describing with respect to the *atal* is precisely this quality of exceeding boundaries. The *atal* was displayed in a museum case, arranged next to other artifacts from Central Africa, yet it could not be contained in that display setting. Removed from its forest setting in central Nigeria, the *atal*'s past history seemed to have died, yet the *atal* transcended itself and this history, coming alive in my imagination and subsequent work.

For Bakhtin, seeking to understand diverse people, nations and cultures can lead to a felt sense of the complex unity of all human cultures throughout time. I do not agree with his view that each individual culture can be simply equated with other cultures elsewhere in the world across time – an assertion that should be clear from my basic question here about 'whose aesthetics' we study. Yet I do feel sympathetic to Bakhtin's larger insight. Whereas our analysis of cultural artifacts 'usually fusses about in the narrow space of small time' (the present, recent past and desired future), images 'must be understood and evaluated on the level of great time' (Bakhtin 1986: 167). As I discuss in Chapter 4, great time is useful for understanding cultural artifacts and even entire cultures. With this term Bakhtin wanted to bring attention to the way dialogue with art never ends. He asserted that a 'text lives only by coming into contact with another text (with context)' (Bakhtin 1986: 162).

I began this chapter by asking whether aesthetic categories derived from European philosophy and art history are adequate for engaging and understanding the art of cultures such as that of the Cross River region in Nigeria. Bakhtin's descriptions of impressive and expressive aesthetics, along with his conviction that aesthetics can serve as a foundation for philosophy, are most

useful for those engaged in philosophical aesthetics. They have limited application, however, when looking directly at art. I believe that it is only through self-conscious reflection and study that one can gain a thorough grounding in cultural artifacts that may be unfamiliar. I understand this through my own direct experience with art and aesthetics out of Africa.

Chapter 2

Creativity and the creative process

In her last book of essays *Opening Our Moral Eye*, M.C. Richards recounted a formative dream (1996: 19). Standing in her vegetable garden, she saw a being with a strange smile and three eyes, about 50 feet away on the compost pile. The right eye was the sun, the middle eye a diamond and the left a huge human eye. Its front teeth were crooked and it had a large benign countenance. In her dream she struggled to find words for her questions: 'When will I...when will my time...what is my destiny?' She immediately went into the studio and made this figure, a literal translation of her nocturnal image. I see this act as an expression of Richards's commitment to holding the ultimate questions in tension with aesthetic creation. M.C. Richards's *Dream Angel* (Figure 3) calls each of us to reflect on our own destinies, about whether we are caught in fantasies of the future or replaying our mistakes of the past. Are we present in the world, fully awake? This work of art also exemplifies the usefulness of three interrelated ideas in Bakhtin's theory of creativity, as we shall see.

Just as Bakhtin avoided clear definitions of aesthetics, he never produced a systematic theory about creativity or the creative process. As I tried to make clear in Chapter 1, his work is both an implicit and explicit critique of all unified and ordered systems. My outline of Bakhtin's views of the creative act and creativity therefore includes more general discussion of the issues raised by his reflections. In what follows I first consider Bakhtin's own life based on an early twentieth-century model of the creative

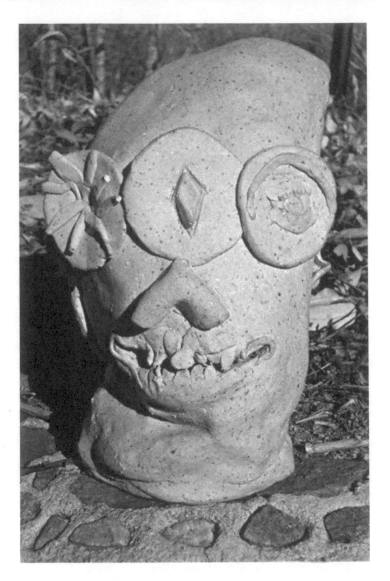

3. M.C. Richards, *Dream Angel* (1960s).

process, then proceed to definitions and paradoxes in the interpretation of creativity. Third, I examine traditional European philosophies of creativity as they evolved in the work of Plato, Aristotle and Kant, since these ideas were key parts of the philosophical framework that Bakhtin inherited. I then analyse how three ideas from Bakhtin's writing of the 1920s – answerability, outsideness, and the degree of finalisability or unfinalisability of a creative act – form the core of his understanding of creativity. Finally, I return to M.C. Richards's observations about *Dream Angel* at the end of the chapter.

Creative cycles in Mikhail Bakhtin's life

At approximately the same time that Bakhtin was writing his first essays, the English scholar Graham Wallas made an attempt to describe creativity as a multistep process (1926). His model was subsequently developed by others, but here I want to examine how it might be useful for understanding Bakhtin's own life and work. Wallas began his study of creativity by defining a series of four to six steps in the creative process that may or may not be sequential, but are usually recursive.

The initial step in a creative process involves preparation and gathering information, which may be conscious and critical or directed by less-willful processes of invention. An artist or writer in any medium must master accumulated knowledge, techniques and skills, gather new facts, observe, explore, experiment and discriminate – all of which are conscious and voluntary activities. In Bakhtin's life several factors laid the foundation for his later creative thought and writing.[1] His family was deeply committed to a broad education in European ideas and culture. Early formative experiences with his brother Nikolai provided passionate intellectual exchanges. Several family moves – from the small town of Oryol where he was born, to the Lithuanian capital of Vilnius, and later to Odessa where tutors introduced him to philosophers such as Martin Buber and Søren

Kierkegaard – combined with the education he received at Petrograd University to stimulate his philosophical and religious development. After he graduated in 1918 he returned to Nevel, where he worked as a secondary school teacher.

In Wallas's model the second phase in the creative process involves incubation, during which the will to create is joined by more intuitive, unconscious and spontaneous dimensions of the process. In Bakhtin's case his mundane work life was balanced by the formation of the first Bakhtin Circle. These meetings with old friends and other young scholars such as V.N. Voloshinov, Lev Pumpiansky and Matvei Kagan were to have an enormously formative impact on Bakhtin's intellectual and religious development. By 1920 a number of this circle's members had moved to Vitebsk, and Bakhtin followed. The details of this period of his life are fascinating, and include the deterioration of his health and his marriage to Elena Aleksandrovna. This was also a period of tremendous productivity for Bakhtin, involving writing, teaching and public speaking.

The third stage is illumination or insight, when new connections are made in what has often been called the 'Aha!' experience. In actual creative processes this type of insight may occur at various stages. Between 1918 and 1924 Bakhtin worked on at least six new essays and longer texts, including 'Art and Answerability', 'The Problem of Content, Material, and Form in Verbal Artistic Creation', and 'Toward a Philosophy of the Act'. As I discussed in Chapter 1, Bakhtin outlined his dispute with Kantian and Neo-Kantian philosophical aesthetics in these three essays, and set forth his emerging conviction that aesthetics should form the foundation for philosophy.

A fourth step in the creative process involves evaluation of what is genuinely valuable and worthy of further development, and decisions about what can be discarded. This stage can be characterised by divergent attitudes, including critical assessment, doubt and uncertainty. In 1924 Bakhtin returned to Leningrad and,

in the years until 1929 he completed four books and a number of articles. Such productivity must have been enormously satisfying for Bakhtin, but in January 1929 he was arrested as part of the persecution of intellectuals during Joseph Stalin's First Five-Year Plan. Due to his bone disease and deteriorating health, Bakhtin was sentenced to a six-year exile in Kazakhstan and ultimately released to recuperate at home. We can surmise that these years of his life were characterised by deep uncertainty.

A fifth step in creative work is elaboration, which is often identified as the most difficult part of the process. At this point a person must engage in the hard work of giving form to ideas and insights. Here especially the recursive aspect of the process comes into play; as fresh insights emerge, new skills must be learned and innovative approaches explored. Bakhtin's life between 1930 and 1945 in Kustanai, and later in Saransk and Savelovo, was one of writing and teaching. In Saransk he was invited to teach at the Mordovia Pedagogical Institute, which became a university in 1957. There he staffed the world literature department by himself for a short time, lecturing on Russian literature, folklore, and medieval, modern and contemporary Western literature, as well as more politically charged topics such as 'Lenin and Stalin on Party-Mindedness in Literature and Art' (Clark and Holquist 1984: 259–60). Bakhtin spent these years elaborating his earlier intellectual insights, giving public form to his philosophy through teaching and lecturing. Unfortunately he was unable to continue teaching in Mordovia due to the purges of the late 1930s.

A sixth stage, which is not always acknowledged among creativity researchers, may involve communication to audiences, viewers and critics, and subsequent external validation of the creative process. Bakhtin's work became known in the West beginning in the 1960s, and his audience therefore expanded. However, significant differences developed among Russian, European and American interpreters of his work. I will further

explore Bakhtin's context and return to this process of reception in Chapter 6.

Other issues further complicate the nature and understanding of creativity. Supported by the research of E. Paul Torrance (1962), Robert Sternberg (1988) and Howard Gardner (1993, 2006) since the 1960s, attempts have been made to examine the role of sociocultural environments in the development of various abilities, including creativity and intelligence. Bakhtin's early essays and his mature work demonstrate respectively the influence of his environment on his productivity, as well as the wisdom that aging brings. His intellectual life supports recent studies that show that age can be a significant factor in creative productivity (Lindauer 2003). Traditional assumptions that creativity usually peaks early in the life cycle have been reversed, suggesting that increasing maturity often enhances creative energy and output. Bakhtin continued to write until a few years before his death. In earlier essays and books he developed formative ideas, but near the end of his life he engaged in more exploratory thinking. In my own reading of Bakhtin's books and articles, I always return to the late essays and notes collected in *Speech Genres and Other Late Essays*, for it was there that he pushed the boundaries of his thought and reflection.

Definitions and paradoxes

Most modern definitions of creativity emphasise qualities of originality, novelty and value, although such definitions can be challenged, as I have already implied. Originality may involve making connections between what was previously unconnected or being open to questioning, ambiguity and unpredictability. Having a positive view of uncertainty with no particular attachment to outcome I know can lead to unprecedented results. Novelty, the ability to create something new, can result from vague, indefinable and mysterious creative processes. Value can be defined both as pragmatic – for example in the sciences and

new technologies – and more intangible – especially in the arts, religion and theology (Rothenberg 1998: 459).

Some definitions of creativity presuppose the idea of an innate capacity, talent or genius, while others emphasise the role of imaginative inquiry and perseverance. I have been impatient for many years with the way ideas about talent have found their way into public discourse and arts education. I certainly would agree that individuals have gifts, proclivities or inclinations that may be nurtured. Skills related to eye–hand coordination are easier to learn for some, while intellectual analysis is easier for others. But determination, diligence, discipline and care also play powerful roles in determining how one's talents are expressed. One must also bear in mind that the so-called 'talent' of particular historical artists must be understood within contexts where patrons and institutional financial support shaped an artist's opportunities. Such disparities in patronage and public support continue to determine who becomes known as creative in various contexts.

All of these definitions of creativity imply comparison. To say that something or someone is creative is clearly a judgement, and judgements are always culturally specific, as I have emphasised. Thus three ingredients are essential to traditional definitions of creativity. First, in terms of the art world, a culture must have been established with both actual and symbolic rules about how to play the game. For instance, the *Global Africa* project, which I mentioned in Chapter 1, set out to challenge these rules by defining the uniqueness of the aesthetic strategies of contemporary African art. Second, a person or collective whose activity is marked by novelty or other values that are highly esteemed within art world culture must have been identified. Third, a group of experts – critics, curators, collectors and the like – who would validate a person's efforts must be active. These last two ingredients in traditional definitions of creativity are evident in the fact that an *atal* from the Cross River region of Nigeria (Figure 1) is featured in a world-class museum such as

the Museum of Fine Arts in Boston, even though nothing is known of the artist who created this sculpture. In sum, an artist must create an object in a particular medium, which is received and interpreted by a viewer or audience in a unique context.

Clearly the context that supports such creativity is crucial, as I have already discussed in terms of Bakhtin's life in Stalinist Russia. Relative material wealth figures in the process since this allows individuals and groups to experiment free from concerns about daily survival. Historically, cultures have tended to foster greater creativity when the beliefs and lifestyles of diverse cultures intersect, thereby allowing individuals to see and create in new ways. Unfortunately, in conditions of exile and literary repression, Bakhtin's creativity was not externally supported or nurtured.

In the end, creativity must be understood as a multifaceted and paradoxical construct with diverse characteristics. Distinct ways of processing information and solving problems may be called creative. Creativity occurs in a variety of domains, from the visual and performing arts to the sciences and religion, and is defined differently in particular disciplinary arenas. The creative process results in a wide range of subjective experiences and objective products – from intangible feelings of fulfilment and self-worth to the production of paintings and sculpture, musical scores and theatrical productions, poetry and novels, and contemplative religious works of art.

There are a multitude of ways in which trying to explain creativity is fraught with mystery and paradox.[2] In Bakhtin's terminology, creativity is ultimately unfinalisable: it cannot be tidily summed up. Creativity is ubiquitous and every person is capable of creative acts, but creativity is also often defined as extraordinary, as occurring outside of everyday life. Bakhtin would have disagreed because he saw creativity as a prosaic everyday activity, accessible to all. Novelty is often identified as the single most significant characteristic of creativity, yet

novelty alone is not sufficient for defining the full range of creativity. Even the idea of a novel physical object as the outcome of creative processes is not universal. Creativity may be applied to new ways of symbolising or to the creation of events or rituals, as well as temporary presentations such as the performances of Marina Abramović, which I discuss in Chapter 3. Another issue is that creative works of art require knowledge and skill, but an artist or performer must simultaneously maintain freedom from the constraints of these conceptual and technical abilities. This freedom is implied in M.C. Richards's *Dream Angel*. A technically proficient artist and writer, Richards purposely created a figure that some might consider unattractive, even ugly.

Many definitions of creativity assume that there must be a creative product or event of some kind, but creativity is often carried out and studied without reference to end products. Ian Hamilton Finlay's *Little Sparta* and Morris Graves's *The Lake*, described later, demonstrate the artists' lifelong commitment to a continuous creative process. As they remain today, the sites create experiences for visitors, but these can never be defined as products since they ultimately cannot be finalised. Both sites continue to be developed, but even if this human activity ceased, nature would transform the land.

Further complicating explanations of creativity is the fact that creative people are encouraged, albeit tacitly, to deviate from traditional social norms. Simultaneously, there are limits to what social institutions and social norms will allow. For instance, I work at a large corporate state university in the United States, which has clearly defined standards of productivity for its faculty. Because I am a professor, exhibitions and/ or publications are the norm for regular yearly evaluations, but such norms are culturally specific and have little to do with the conditions under which artists in other traditions outside of the European West might work. Sculptors who worked on stone *atal* in Central Africa or *thangka* painters who painted religious

images in old Tibet followed norms and values that were also culturally specific. I therefore urge aspiring artists to reflect carefully about how the context in which they choose to work determines values. Clearly, creativity can result from opposite types of motivations, from seeking self-aggrandisement to creating as a gift, from seeking external recognition to treating creative work as contemplative practice. To paraphrase poet Robert Frost, the course or path of creativity that an individual artist takes will make all the difference.

Finally, creativity often requires combining personal characteristics that would seem to contradict one another. For instance, humility and modesty or deep self-confidence and self-assertion may characterise, in turns, a given creative process. Some artists and writers are self-effacing, while others seek stardom. We have no universal standards for interpreting and comparing the creative output of such artists and scholars whose work moves in opposing private and public directions.

Bakhtin's creative work and creative process exemplify many of these definitions and paradoxes. He lived through the major Soviet cataclysms of the twentieth century, yet his own ideas evolved slowly. He wrote few letters, avoiding the telephone and formal interviews. He left no diary or memoirs from which others could discern creative patterns in his life. He rarely spoke about personal experiences, and in public his speaking style was restrained and formal, yet authoritative. In writing he eschewed scholarly apparatus such as footnotes and documentation. He did not enter print debates about his work, which was often harshly reviewed. In later life he was reclusive and increasingly immobile due to illness. He spent his life in dialogue with ideas, returning in his final decade to questions he had addressed in his youth. His creative process was idiosyncratic and private, yet it has led to a Bakhtin industry awash in 'gossip, turf wars, unsubstantiated rumour, dialogue in bad faith, nostalgic fantasy, and willful misreadings' (Emerson 1997: x).[3] Still, Bakhtin's work

has resulted in an international centre with an extensive website, scholarly publications and ongoing conferences, all of which testify to his profound and generative creativity.[4]

Philosophies of creativity

Turning now to philosophies of creativity, I begin with the backdrop against which Bakhtin's ideas evolved. In cultures of the European West, three major conceptions of creativity can be traced to Plato, Aristotle and Kant, respectively. The earliest discussion of creativity in the arts can be found in Plato's short dialogue, the *Ion* (1983). There, Plato suggests that creative activity is dependent on a muse or external divine power that provides inspiration for the performer, poet or artist. But Plato's view of inspiration and creativity cannot be separated from his understanding of imagination. In texts such as the *Republic* (1966), he articulated a view of imagination as an inferior capacity of the mind, a product of the lowest level of consciousness. The visions of poets such as Homer, as well as the products of artistic creativity more generally, were part of the mantic or irrational world of belief and illusion. As such, they were inferior to philosophy and mathematics, which were higher forms of knowledge. For Plato, human creativity was therefore mimetic and derivative, never able to claim access to divine truth.

In contrast to this idea, Aristotle developed the notion of art as craft, a process whereby the artisan's plan is imposed on a material to create an object but not necessarily a new form or new thing. If Plato was mainly concerned with protecting the polis from the problems of idolatry, Aristotle's contribution to developing ideas about creativity and imagination must be seen on a more psychological level. In texts such as *On the Soul* (1935) and *On Memory and Recollection* he shifted attention to the psychological workings of imagination, interpreting it primarily as the capacity to translate sense perception into concepts and rational experience. Because of our imaginative images and thoughts we

are able to calculate and deliberate about the relationship of things future to things present, which has enormous implications for creative activity.

In Chapter 1 I emphasised the Kantian and Neo-Kantian bases of Bakhtin's thinking. Here I expand on Kant's articulation of creativity as a function of genius, which established a third model that has been influential in all subsequent European-based approaches to artistic creation. According to Kant, a genius is capable of establishing new rules, developing new works of art and evolving new styles. These processes are thoroughly dependent on imagination. Like the Greeks, Kant saw imagination as the mediator between sense perception and concepts, but he also insisted that it is one of the fundamental faculties of the human soul. Without the syntheses of imagination we would be unable to create a bridge between sense perception and thinking, all of which make creativity possible.

There is an essential difference between Greek conceptions and Kant's distinctly modern view of creativity and imagination. Whereas premodern philosophers saw imagination as dependent on pre-existing faculties of sense perception and reason, modern philosophers such as Kant posited the imagination as an autonomous faculty, both prior to and independent of sensation and reason (Kearney 1988: 111–12). In his *Critique of Pure Reason* and the *Critique of Judgment*, Kant described imagination as a free, playful and speculative faculty of the mind. This free play leads to artistic creativity, as Romantic philosophers such as Samuel Taylor Coleridge would also argue (1965: 167, 202).

All of these ideas have been enormously influential in subsequent European philosophies of creativity. Since becoming a subject of analysis in the late nineteenth century, creativity has continued to generate much interest across disciplines. By the twentieth century the word 'creator' was applied to all of human culture, including the sciences, new technologies and politics. The word 'creative' may also be applied to diverse cultural

practices. Are the indigenous folk arts of India, for example, less creative because they build on ancient traditions or because they are made for daily use? Are Russian Orthodox icons or Himalayan Buddhist *thangkas* less creative because artists follow strict patterns and iconometric diagrams? Some would say that these artifacts remain crafts by virtue of their use, but I find such assumptions elitist and demeaning of the creative human spirit.

Bakhtin's view of creativity and the creative process is based on these European definitions, and is best understood through examining his ideas of answerability, outsideness and unfinalisability. With the concept of answerability, Bakhtin emphasised that we are not obligated by theoretical norms or values, what he called *theoretism*, but by real people in real historical situations. A genuine life, and genuine art, can only be realised through concrete responsibility toward others. By the late 1920s the general notion of answerability would be replaced by dialogue and the dialogic, both of which have stronger linguistic valence.

In 'Art and Answerability' Bakhtin made an attempt to articulate the importance of responsibility or answerability (1990). Following a Kantian framework, he stressed that the three domains of human culture – science or reason, ethics or the life of action, and art or aesthetics – can be united in an individual, but that this unity can be either external and mechanical, or internal and organic. Like any person, the artist can make an external connection between the self, art and the world, thus creating a falsely self-confident art that does not and cannot answer for life.

Yet to make an inner connection between art and life necessitates answerability: 'to answer with my own life for what I have experienced and understood in art, so that everything I have experienced and understood would not remain ineffectual in my life' (Bakhtin 1990: 1). From this perspective, experience and understanding must be linked to activity in a life. It is easier

to create if one does not attend to the situation in life ('without answering for life'), and vice versa: it is easier to live if one doesn't think much about art (1990: 2). His goal in this essay was to point out that through a process of consistent response- or answer-ability, art and life can be unified by and in the person. Bakhtin's meditations on life were very general. In this short essay he began a pattern that he would follow for years to come, a pattern of not addressing the specifics of a given situation – its politics, economics, class and so forth – while simultaneously urging that the uniqueness and particularity of each person were of prime importance.

Answerability is Bakhtin's term for the process of mutual response, answering, that happens between two persons or between art and life. The need to answer the other responsibly implies obligation. Such obligation is never solely theoretical, but is an individual's concrete response to actual persons in specific situations. Thus for Bakhtin, answerability is the name for individual responsibility and obligation that leads to action for ourselves, of course, but also on behalf of others. Bakhtin's understanding of the centrality of answerability in creative processes echoes artist M.C. Richards's assertions about the necessary dialogue of art and life. In Richards's work, which I encountered in the late 1960s, I first heard this vision articulated. 'Life is an art', she wrote in her book *Centering*, 'All the arts we practice are apprenticeship. The big art is our life' (1969: 40–41). Art, Richards insisted, is a moral eye that opens and closes, helping us to truly see what matters around us (1969: 6). At the centre of her vision there was no product to sell, no 'specific object' such as minimalist artists touted in the 1960s, no appropriation of other artists' work, but a process of relationship of self and other in the world.

But if answerability is the fundamental goal of the artist's creativity, then outsideness is what makes that goal possible. Bakhtin's interpretation of outsideness was articulated as a

corrective for aesthetic empathy. Empathy, especially as it had been interpreted by nineteenth-century German aestheticians such as Theodor Lipps, tends to emphasise identification with and melding of one consciousness with another. Most of us know what this means. When a hardworking friend tells us that he is angry about his supervisor's decision to promote another employee, we may automatically identify with our friend's emotion and its rightness in his unjust situation. Empathy assumes that melding with another's consciousness or coexperiencing an event with another person is sufficient as grounds for moral action. In Bakhtin's view, this kind of empathy is not actually possible given the facts of spatial and temporal specificity, what we might call particularity, of each person in any given moment.

Unlike empathy, Bakhtin's notion of outsideness tries to take account of the necessary separation between persons. We may 'feel ourselves into' or empathise with the experience of another person, but Bakhtin was convinced that it is essential to return to and maintain one's own unique position outside of that person's experience. Indeed, by emphasising the boundaries that separate one consciousness from another, we are actually more able to act with and on behalf of the other person. Bakhtin's convincing example of this concerns how we experience the suffering of another. According to Bakhtin, one first projects oneself, experiencing what the other experiences, insofar as this is possible. 'I must appropriate to myself the concrete life-horizon of the person as he experiences it' (Bakhtin 1990: 25). But even this act entails more than one can see. For instance, the viewer sees the facial expression and the physical background of the one who is suffering. The other person does not see her or his own body, the expression of suffering, the body posture and so forth. The viewer's experience finalises the experience of the other insofar as it fills in the gaps in the horizon where the other cannot see.

Merging with the other or coexperiencing another's joy or pain is not the goal in Bakhtin's model. An experience with

another person's suffering may prompt ethical action, but the initial experience must be followed by a return to the self since only from that outside place is suffering rendered meaningful. Moral and aesthetic activity *begins* when returning into oneself. These moments of empathy and outsideness are not necessarily sequential or chronological. They fuse together and are intertwined, though at a given moment in time one will dominate over the other. For Bakhtin, simply to experience empathy is inadequate as a basis for moral action. One may feel pain or outrage but effective action, especially the ability to act on behalf of another to alleviate suffering, is the result of the complex interplay of cognitive, moral and aesthetic decisions.

Thus, boundaries are a fundamental element in Bakhtin's description of outsideness in the creative process. In a personal sense, boundaries between the self and the other define the body in space. A boundary is first a line that delineates the other's body against a background, but this line is imperceptible to oneself. As he asserted, 'I am situated on the frontier of the horizon of my seeing; the visible world is disposed before me' (Bakhtin 1990: 37). A person can see her horizon, but not her environment – the world as it is seen by another outside the self. In order to experience the world in its diversity and richness, the self therefore needs the other who exists outside of her.

More broadly, creativity itself is only possible on and because of boundaries between persons, events and objects. In Bakhtin's words, 'A cultural sphere has no inner territory. It is situated entirely on boundaries; boundaries go through it everywhere... Every cultural act lives on boundaries: in this is its seriousness and significance' (Bakhtin 1990: 274). The meaning of a creative act evolves in relation to the boundaries – the inside and outside – of the cognitive, ethical and aesthetic spheres of culture. Indeed, creative activity must be understood in relation to the unity of culture and to life itself. As Bakhtin repeated many times in subsequent writings, this sense of the interconnectedness of self and other, text and

context, cultural artifacts and daily life forms the foundation of the creative process. To speak of art and the creative process as radical presence, as M.C. Richards did, is another way of articulating this linkage of self and other in the world.

Continuing the discussion of Bakhtin's philosophy of creativity, I move to unfinalisability, a condition that results from the fact that we are finite human beings and have finite knowledge. What we apprehend are constructions, and inevitably conflicts arise over these constructions. Therefore no one person or one group can contain the truth because we simply cannot see everything that is. In his early essays Bakhtin was ambiguous about the degree of finalisation that is possible. On the one hand, he differentiated between the problematic and even immoral attempt to finalise another person, except in death. To do this would deny the other the possibility of full becoming as a person. On the other hand, he emphasised the multifarious ways in which we need the other to create and finalise ourselves. In artistic creativity aesthetic finalisation is essential. When he wrote his 'Response to a Question from the *Novy Mir* Editorial Staff' and 'Toward a Methodology for the Human Sciences' in the early 1970s, both of which were later published in *Speech Genres*, the valence had clearly shifted toward the unfinalisability of creative activity.

Unfinalisability may help us to articulate complex answers to questions about particular works of art: When is a work finished, and when is a critical perspective or audience reception complete? The fact that sculptures such as the Samothracian *Nike* or paintings such as Leonardo's *Mona Lisa* have continued to generate scholarly and public interest for centuries verifies the central insight of Bakhtin's concept. In Bakhtin's formulation the sense of freedom and openness that is encompassed by the idea of unfinalisability applies not only to works of literature and art, but it is also an intrinsic condition of our daily lives. Ultimately, the unrepeatability and open-endedness of creative acts make personal transformation possible.

According to Bakhtin, creativity is ubiquitous and unavoidable, and, as noted earlier, it should not be separated from one's responsibility toward others in the world. What can ever be fully finalised? There is always a tentative quality to one's work, one's action and to life itself. Unfinalisability therefore has at least two distinct levels: the ways we need others in order to finalise the self; and the ultimate unfinalisability of all things, events and persons. Art and life are ultimately open-ended. Even though a person's life is finalised in death, that person's work lives on to be extended and developed by others, an insight we certainly understand in relation to significant historical artworks. The creative process too is unfinalisable, except insofar as an artist says, somewhat arbitrarily, 'I stop here'. Precisely because it is always open to transformation, artistic work can be a model for the possibility of change in the larger world outside the studio. Indeed, unfinalisability gives us a way to speak about the problems of representing the changing world through the artistic lens of our diverse and ever-changing subjectivities.

Bakhtin's appreciation for unfinalisability is echoed in Richards's commitment to creating in multifarious ways until the end of her life. She was a translator, poet, essayist, potter and painter. Born in 1916, she taught at Black Mountain College in the late 1940s and thereafter became an impassioned advocate of community. For the 15 years before her death in 1999 she lived at Camphill Village, an agricultural community in Pennsylvania based on the work of anthroposophist Rudolf Steiner. Although she published other books, including poetry, and exhibited her art, *Centering* became an underground classic. Here she pulled together ideas about art and craft, education and creativity, religion and spirituality, arguing for the interconnection of art and life and the creative potential of every person. Her writing and her art demonstrate how these values might take form in a daily life, even as it is underway and unfinished.

Where does the lack of specificity in Bakhtin's definitions of creativity and the creative process leave us? As I have already implied, creativity is difficult to define because it is so complex and multivalent. Should we, like Bakhtin, therefore abandon attempts to theorise these processes? The answer of M.C. Richards's *Dream Angel* to her questions that opened this chapter is pertinent here: 'I wouldn't worry about that if I were you'. What exactly should we not worry about? Near the end of a film documentary about her life, *The Fire Within*, Richards muses about this: 'I often wonder, not exactly *what* am I doing, but is it *enough*? Is this enough to be doing in the world when the needs are so great? You know, to be messing around with creativity?' Keeping in mind Bakhtin's concepts of answerability and unfinalisability, *and* the *Dream Angel*'s words, I believe that we should simply proceed with our inquiries about creativity and creative processes. In writing much later about her dream and this small clay sculpture, Richards suggested that the three wide-open eyes integrate the warmth of the sun and the essence of the diamond with human vision. All three eyes look at us with affection and wisdom as we make an effort to awaken. 'They know we are on our way', Richards wrote, 'The angel smiles' (1996: 11).

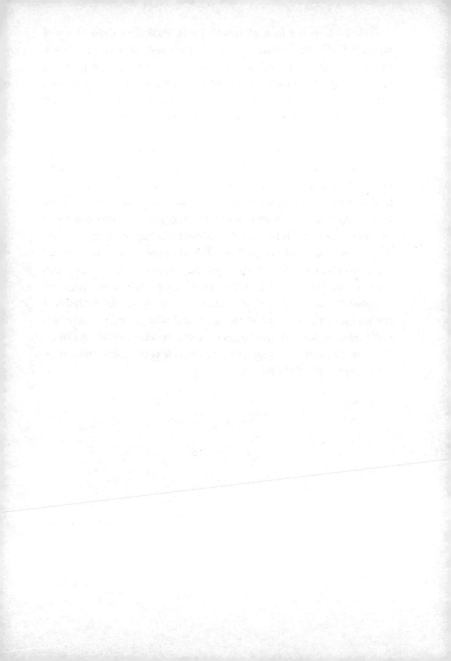

Chapter 3

The artist

Born in 1946 in Serbia, Marina Abramović began her career in the early 1970s. Her earliest works were sound environments and photographs, but by 1973 she had begun formal performances, many of which lasted up to eight hours. In 1976 she began a 12-year collaboration with the artist Ulay (Uwe Laysiepen) that ended with the 90-day 'Great Wall Walk', where each artist traversed 1,553 miles (2,500 km) to meet in the centre of China's Great Wall. After a hiatus of a few years, Abramović returned to creating performances and videos. Along with artists such as Rachel Rosenthal and Carolee Schneemann, she is one of the grandmothers of performance art. In 2010 she became the first performance artist to be honoured with a retrospective at the Museum of Modern Art (MOMA) in New York. In general, her work explores the interrelationships of performer and audience; the limits of the body, including working with pain; and the possibilities of working with the mind in complex situations.

Abramović's exhibition at MOMA, *The Artist Is Present* (Figure 4), took place from 14 March 2010 until 31 May 2010. During this period she sat in a chair for 600 hours, first at a table in the museum atrium where visitors would come, one at a time, to sit facing her. Near the end of April, however, she had the table removed in order to simplify the setting. As she said in an interview at the end of the exhibition,

I had a man with a wheelchair and in the middle of this piece I realised that I didn't even know if he had legs... So I decided to remove the table and...then the piece started having sense to me. I know now that I'm really interested more and more in immaterial art. (Stigh and Jackson 2010)

This work of art was, as Abramović said, 'about stillness and about literally doing nothing and being in the present'[1] (Stigh and Jackson 2010). Abramović had earlier created silent durational performances involving time. For instance, she and Ulay performed *Nightsea Crossing* 22 times between 1981 and 1987, for periods ranging from one to 17 days. Like *The Artist Is Present*, *Nightsea Crossing* also involved extended sitting, watching the sense of presence rise and fall in consciousness.

Abramović's creative work has numerous antecedents, including contemplative sitting in Buddhist Japan, Christian

4. Marina Abramović, *The Artist Is Present*
(2010), Photograph © Marina Abramović.

ascetic traditions, sit-ins during the American Civil Rights Movement, and, most notably, Greek and pagan Balkan cultures in which 'magical sitting' was practised (Biesenbach 2010: 15). Certainly Marina Abramović's retrospective exhibition and her long performance reinforced her stature as an artist, but the exhibition also offered an unusual opportunity to challenge viewers with questions about the purpose and meaning of being an artist.

In this chapter I further develop Bakhtin's notion of answerability by showing how he extended it with linguistic concepts such as dialogue, the dialogic and polyphony. I also look at how ideas around ideology and difference provide a useful counterpoint to his description of outsideness. All of these ideas are useful for artists as they consider their own purpose and potential legacy, and for art historians who assess the contribution of particular artists' work. At the end of the chapter I return to Abramović's performance in order to muse about the problem of the artist's ego.

From answerability to dialogue

The ideas described in Chapter 2, which form the basis for Mikhail Bakhtin's interpretation of creativity, also demonstrate the complex dynamics of self, other and the world. In Bakhtin's early essays this sense of the relationship of self and other was expressed with the concept of answerability. Art and life answer to each other much as human beings answer each other's needs and inquiries in time and space. Answerability was his way of naming the fact that art, and hence the creative activity of the artist, is always related, *answerable*, to life and lived experience. For him the idea that we are answerable, indeed obligated, through our deeds is the basis of the architectonic structure of the world and the basis of artistic creativity. As I emphasised in the last chapter, Bakhtin's interpretation of creativity highlights the profound moral obligation we bear toward others. Such

obligation is never solely theoretical, but is an individual's concrete response to actual persons in specific situations. Because we do not exist alone, as isolated consciousnesses, our creative work is always answering the other. Answerability contains the moral imperative that the artist remain engaged with life, that the artist *answer* for life. At every point Bakhtin insisted on obvious ethical aspects of self–other relations in creative work.

Whereas answerability was a broad concept in his early essays, Bakhtin developed a more linquistic interpretation of this process in his book on Dostoevsky. There he began writing about dialogue and the dialogic. The concept of dialogue lends itself to facile application because everyone has a common-sense understanding of what it is: an individual talks, another person listens, responds, and the conversation proceeds. In a work of art an artist enters into dialogue (in actual, historical or mythological time) and expresses something about a place, person or event. Bakhtin, however, meant more than just the simple exchange of ideas, words or images. Dialogue and the dialogic are perhaps the most misunderstood of his concepts, not least because he invoked the terms in many contexts and over many years (Bakhtin 1986: xvii).

As Gary Saul Morson and Caryl Emerson have shown, Bakhtin used the concept of dialogue and the dialogic in at least three distinct ways (1990: 130–31). First, dialogue refers to the fact that every utterance is by nature dialogic. An utterance can never be abstract, but must occur between two persons: speaker and listener, creator and audience, artist and viewer. It is always directed at somebody in a living, concrete, unrepeatable set of circumstances. For instance, a Himalayan Buddhist *thangka* is directed toward the Buddhist practitioner, whose 'dialogue' with it involves visualisation and recitation of texts. The paintings of Claude Monet may be interpreted as a dialogue with his contemporaries, artists such as Auguste Renoir, Édouard Manet, Berthe Morisot, James Whistler and John Singer Sargent, and with his critics and dealers.

As an example of how an artist might enter into dialogue with historical events, consider Abramović's 1997 performance *Balkan Baroque*. In this piece she scrubbed clean 1500 bloody cow bones while singing folk songs and weeping. She performed these actions for four days, six hours each day, at the 47th Venice Biennale where she received the Golden Lion Award for best artist. The performance has been interpreted as the artist's response to the Balkan Wars involving Bosnia, Croatia, and Serbia, where she was born. Drawing on personal experience and reflection, Abramović's dialogue was raw and visceral.

Understood as utterances that are directed to someone in a unique situation, dialogue can be either monologic or dialogic. This is the second way in which Bakhtin used the term. Although his discussions sometimes lack clarity, monologism means that dialogue becomes empty and lifeless. As he wrote in 'Notes Made in 1970–71': 'Take a dialogue and remove the voices...remove the intonations...carve out abstract concepts and judgments from living words and responses, cram everything into one abstract consciousness – and that's how you get dialectics' (1986: 147). Bakhtin argued that modern thought, including literature and art, has been dominated by a narrow dialectical monologism and by monologic conceptions of truth.

I have repeatedly asked myself whether and how visual art can be monologic, and I think the answer to this question concerns the construct of the 'artist'. The idea of the artist is usually structured around several notions: the artist as original genius and unique bearer of talent; the artist as creator who imitates the divine in the creative act; or the artist as magician who fools the viewer by copying reality in some way. Such myths of the artist as genius, creator or magician depend upon 'heroisation' of the artist through a focus on biography (Kris and Kurz 1979). Contemporary artists such as Martha Rosler, Louise Lawler and Sherrie Levine have challenged such traditional notions of the artist by directly appropriating the images of other artists in their work.

In her work of the 1980s, for example, Levine scavenged and appropriated images of many artists, including Stuart Davis, Arthur Dove, Walker Evans, Andreas Feininger, Ernst Kirchner, Willem de Kooning, Ferdinand Leger, El Lissitzky, Kasimir Malevich, Henri Matisse, Piet Mondrian, Eliot Porter, Alexander Rodchenko, Egon Schiele, Vincent van Gogh and Edward Weston. Her tactics involved taking photographs of other artists' work, cutting out magazine or announcement reproductions, or painting her own watercolours of earlier works. In 1980 Levine pirated one of Edward Weston's photographs of his son Neil by copying a poster published by Weston's gallery in New York City. When attorneys for the Weston estate saw this image and threatened a lawsuit, Levine responded by turning to other artists whose work was not copyrighted. At least in the 1980s and 1990s, Levine's name became synonymous with a certain kind of appropriation. On the surface, her practice seems to reflect the kind of monologism that Bakhtin decried. Yet Levine was articulate about her working process: 'A lot of what my work has been about since the beginning has been realising the difficulties of situating myself in the art world as a woman, because the art world is so much an arena for the celebration of male desire' (Siegel 1985: 142). Her appropriated image of the Weston photograph attempted to subvert the institutions that govern discourse in the art world. Clearly Levine's work cannot only be called monologic because it remains part of a larger dialogue about the politics of the art world. From one perspective Levine may be a thief, but she is also a critic.

In Levine's early work we may be able to see a quality that Bakhtin called polyphony. Dostoevsky, Bakhtin claimed, was the first truly polyphonic writer because he wrote using paradoxes, differing points of view and the interplay of unique consciousnesses (1984a). To be polyphonic, communication and social interaction must be characterised by contestation rather than automatic consensus – a circumstance that is clearly visible in Levine's scavenged photographs.

In various media such as painting and performance, the gaze itself can become explicitly dialogical and polyphonic. In the 1980s, for example, Leon Golub (1922–2004) painted *Mercenaries and Interrogation*, a series of images about human rights violations in Central America that included scenes of mercenary soldiers, interrogation and torture. The US government supported death squads in Nicaragua and El Salvador in the 1970s and 1980s, and the artist used actual historical events as the basis for the series. The paintings are larger than life, the images grim. The gaze of a person being tortured appeals to the viewer, while the interrogators seem to taunt us with their violent intent. In Golub's paintings the viewer is addressed explicitly, as characters look out and engage the viewer in the midst of scenes of brutality and torture. They query us; they ask us to account for ourselves. Golub refused to frame his paintings because he believed that would make them more precious and presentable as museum objects. If the artist had been most concerned with commercial success he might not have made such a decision. Instead, he focused on the artist's responsibility to present what actually happened.

Analogously, the politics of the gaze is implicit in Marina Abramović's *The Artist Is Present*. With the expressed purpose of creating a situation for silent encounter, she established a profoundly dialogical situation in which the artist, the individuals who sat with her, the larger audience and museum personnel all interacted in a multilevelled and multivoiced dialogue – a polyphony.

Polyphony presupposes the third and most general sense of dialogue. Bakhtin understood life itself as dialogue: 'To live means to participate in dialogue: to ask questions, to heed, to respond, to agree, and so forth' (Bakhtin 1984a: 293). We participate in such dialogues our entire lives, with our senses, our bodies and limbs, and through the acts we undertake. Ultimately, discourses with the self, with others and with events, shape the dialogical fabric of human experience in the larger world. Dialogue is therefore

epistemological. Only through dialogue do we know ourselves, other persons and the world. Working with paint and canvas, with chisels and stone, with earth and sticks, or with voice and body in a performance piece, an artist engages in a dialogue with her or his perception, and then shares knowledge about the world in both direct and indirect ways. Works of art may thus express not only a profoundly answerable and dialogic relationship with persons and with the environment, but they may also be interpreted in relation to time, duration and change.

There is a distinct relationship between Bakhtin's understanding of the dialogic and philosopher Martin Buber's articulation of I–Thou relations. Bakhtin had first studied Buber, who was 20 years his senior, while he was in his teens. Both men were deeply influenced by Neo-Kantian philosophy, Bakhtin as a Russian and Soviet citizen, Buber as a Hasidic scholar. Both men's thought was indebted to German Neo-Kantian Hermann Cohen (Perlina 1984: 13–14). I mention this fact here simply to link them to Cohen dialogically.

According to Bakhtin, experiencing the self is fundamentally different from the way one experiences others, both in our lives and in imagination. We lack any approach to ourselves from outside the self, and therefore the sense of who we are always remains somewhat hollow. One can represent the self, but it requires a special effort. An uncomfortable 'doubling' may occur, what Bakhtin identified as a peculiar 'emptiness', 'ghostliness' or 'solitariness' that indicates a self encountered in isolation from the world, inner feeling and will (1990: 30). In traditions of portraiture, which includes works of art in many media across time, we see both monologic and dialogical possibilities for representing the self. Bakhtin articulated a hierarchy of strategies based on the relative adequacy of four main types of representation. Self-perception in a mirror, representation in a self-portrait, and a photograph by another: these three representational strategies fail to signify that the self is or can

be a consummated whole. Only when one's portrait is painted or sculpted by another person can a different relationship be established, and this is the fourth possibility. How did he arrive at this conclusion?

Before a mirror we see an external reflection of ourselves that has three aspects. First, a face can reflect one's present attitude as well as feelings and desires. We make a glum face or smile. We don a mask or costume. Each of these examples reflects an attitude. Second, we may imagine the evaluation of another person who is witnessing our performance. Third, one's reaction to this imagined assessment may be experienced as pleasure or displeasure, satisfaction or dissatisfaction. Additionally, a possible fourth reaction is implied here, that of 'attitudinising'. As Bakhtin suggested, by posing or making faces that we think will be acceptable to others, 'we evaluate our exterior not for ourselves, but for others through others' (1990: 33). All of these 'faces' demonstrate that one is never really alone when looking in a mirror. A second person or second consciousness is always implied. An imagined or fictitious other is present, even in self-contemplation.

This kind of posturing is clearly evident in artist Cindy Sherman's working process, where the mirror is her primary studio assistant. As she said in a 1985 interview,

I think I'm *becoming* a different person. I look into a mirror next to the camera…it's trance-like. By staring into it I try to become that character through the lens… But something happens that makes it more fun for me because I have no control over it. Something *else* takes over. (Sussler 1985)

Bakhtin would have considered Sherman's photographs to be more pure than a reflection in a mirror, but still not able to express the artist's 'essential emotional and volitional stance in the ongoing event of being' (1990: 34). A photograph can function as a form of

raw material, but can never carry a deeper sense of dialogue because, in his view, the viewer is implied but not present.

Bakhtin believed that one could almost always distinguish a self-portrait from a portrait by another. In a self-portrait, he said, there is a ghostly character in the face because it can never encompass all of the person that could be seen and represented by another artist (1990: 34). Perhaps Bakhtin is right in observing that a self-portrait cannot be complete in the same way that a portrait by another can be. I see the truth of his claim that we can never see the entirety of ourselves. In actuality, however, it is not so easy to discern differences between these two kinds of portraiture, as we can see by considering Rembrandt van Rijn's process in relation to Sherman's. Although he did not elaborate on his remarks, Bakhtin briefly mentioned self-portraits by Rembrandt.

From the outset of his career in the 1620s until his death in 1669, Rembrandt painted more than 40 portraits of himself before a mirror, etched 31 self-portraits and drew his portrait a handful of times (White and Buvelot 1999: 10). This extensive production is unique among modern artists. Scholars continue to speculate on why Rembrandt made self-portraiture such a focus of his studio practice. In the 1960s art historian Manuel Gasser speculated that Rembrandt's many self-portraits were a means of gaining self-knowledge that 'took the form of an interior dialogue: a lonely old man communicating with himself while he painted' (1963: 88). In this sense we might imagine Rembrandt's work as a forty-year exercise in self-analysis, as many viewers and critics continue to think. However, more recent scholarship has offered other interpretations.[2] Some scholars see his sustained self-portraiture as a mark of Rembrandt's individuality prior to the eighteenth-century Enlightenment with its focus on the individual, reason and empirical science. Others see his work as representing the failure to find favour with the court and traditional patrons, as indicating his successful independence and manipulation of the market, or as a way to demonstrate his artistic prowess. At the

5. Cindy Sherman, *Untitled #466* (2008),
Photograph © 2011, Courtesy of the artist
and Metro Pictures, New York.

very least, by using himself as the model in widely distributed etchings as well as in his drawings and paintings, Rembrandt made himself into a recognisable celebrity at the same time that he demonstrated his exemplary technique.

A striking similarity can be seen between Rembrandt's paintings and Sherman's *Society Portraits* of 2000–8 (Figure 5). While the camera might be considered a more objective eye than the artist's own, both artists' work contains a degree of attitudinising that comes from looking at one's image in a mirror. Rembrandt's costumes were not random but were selected with an eye for the formal and fashionable. As Marieke de Winkel observed, 'Some may have served as a form of self-promotion, while others were deliberate attempts to carve out a place for himself in a long tradition' (in White and Buvelot 1999: 72). The same can be said of Sherman's series of *Society Portraits*, some of which were included in her 2012 retrospective exhibition at the MOMA in New York. Manipulating her face and body to emphasise both age and wealth, Sherman has created a powerful irony. As one reviewer noted, 'These doyennes are not unlike the collectors whose support makes possible extravagant shows like this one at MOMA' (Woodward 2012).[3]

As noted earlier, Bakhtin claimed that if one's portrait is painted by another artist a different relationship can be established. Here, he said, is the other who can finalise me, who has a 'window into a world in which I never live'. The artist offers a form of 'seeing as divination', a seeing that can shape and even predetermine the self (1990: 34). In other words, only a portrait created by another can represent a consummated or finalised self because that person can genuinely see the exterior surrounding world. Although a plastic or pictorial portrait is a more complete representation than is possible through a mirror, self-portrait or photograph, Bakhtin claimed that it is still limited because it cannot demonstrate change through time. With the exception of film and digital media, his claim is true of the visual arts in

general because they are not linear or sequential. By contrast, a portrait given in a verbal or written text can show change and transformation over time (1990: 35).

One major lacuna in Bakhtin's consideration of various forms of portraiture is the idea that there is inevitably an element of deception in *any* portrait. As art historian Richard Brilliant has observed, most portraits do not represent the transitory flux of emotion and thought because they are more focused on capturing the self as a stable identity. By extension, there can be a 'sanitising' of expression since portraitists usually avoid unpleasant qualities in their subjects (1991: 112). In this way most forms of portraiture are actually a kind of mask making, creating a public image that may or may not be true to the person in everyday life.

We can see this process at work in Sherman's many self-portraits from the 1980s to the present, which demonstrate clearly that identity itself is slippery and ambiguous. Who *is* Cindy Sherman? What is she like? What does 'she' really look like? Personal identity, the body and appearance, the mind, even reputation: none of these can actually be fixed and finalised. It seems to me that Sherman critiques the self-portrait even as she enjoys the stature she has attained by making self-portraiture the centre of her studio practice. Although we have no direct evidence about why Rembrandt represented himself so many times over so many years, his work can be understood as a way of challenging life's impermanence and expressing the wish for immortality.

Yes, we then might say with Bakhtin, the self needs the other 'for the other's seeing, remembering, gathering, and unifying self-activity [is] the only activity capable of producing his outwardly finished personality' (1990: 35–36). The self is given shape by the other. Aesthetic activity is therefore productive because it gives birth to the full human being. The complexity of this process is exemplified in the images I have discussed thus far. Bakhtin's concept of outsideness allows us to deepen our comprehension of how this process occurs.

From outsideness to difference

As I outlined in the last chapter, Bakhtin used the concept of outsideness to criticise and balance Neo-Kantian notions of aesthetic empathy and identification. For Bakhtin, aesthetic and moral activity only begins after empathy, which he interpreted as a kind of living-oneself-into the experience of another person. Only with the return into the self and with clear boundaries between the self and other do we begin to form and consummate the experience derived from projecting the self into another's position.

Bakhtin understood outsideness as crucial for moral action on behalf of others, including when we might wish to help alleviate the other's suffering. However, his view is problematic. For example, Bakhtin asserted: 'The clear blue sky that enframes him [the one who suffers] becomes a pictorial feature which consummates and resolves his suffering' (1990: 25). Suffering, real suffering, is not resolved by seeing it against a clear blue sky. This act may resolve *my* feeling about the other's suffering, but it does not in any way resolve the *other's* suffering. Further, Bakhtin did not offer any way of understanding how structures of power influence and inflict suffering on scores of others. Such suffering is not so easily mitigated as Bakhtin would like us to think. Not surprisingly, given his cultural context in Stalinist Russia, his analysis of the phenomenology of self–other interactions failed to acknowledge how power dynamics inevitably influence those interactions or the ways in which they are ideological.

Although Bakhtin was interested in the role of ideology in creative activity beginning in the late 1920s, to him ideology was simply an idea system that involved the concrete exchange of signs in society and throughout history (Bakhtin 1981a: 429). Ideology was a particular form of monologic thinking, subject to the same kinds of problems and limitations as religious monotheism. Put simply, Bakhtin did not analyse ideology in terms of the representation of difference. However, by highlighting ideas of otherness and difference, late twentieth-century feminists have

significantly amended and corrected Bakhtin's description. The discussion of difference within feminist theory, however, is neither monologic nor monolithic.

The literature on this subject is vast and growing, as a survey of current feminist journals such as *Signs*, *Feminist Studies*, *Genders*, *Differences*, and *European Journal of Women's Studies* will attest. I have found most compelling those discussions that examine how differences – whether based on sex, gender, race, culture, class, age, sexual preference or physical ability – are inscribed through complex ideological processes. In their early analyses from the 1980s and 1990s, feminists were able to use Louis Althusser's definition of ideology. For Althusser, ideologies that influence both individual and collective life are not only ideal or spiritual, but they are also material. They exist within an apparatus of power relationships related to institutions such as the state, church and corporation, and through the practices and rituals that sustain those power relationships. Further, ideologies 'recruit' individuals and 'transform' them into subjects by an operation that Althusser called *interpellation* or hailing. An example of interpellation can be experienced when someone hails us, such as a police officer who yells across the street: 'Hey, you there!' (Althusser 1971: 174). In that moment one is transformed into a subject in a power relationship. While this process of hailing may appear to take place outside of ideology, it is actually ideological.

Ideologies are also made visible through representations. As Marita Sturken and Lisa Cartwright have suggested (2008), ideology presents itself (or, more accurately, is presented by someone) as a complex of common-sense and self-evident propositions about the world. But it is actually an arrangement of social practices and systems of representations, materially operative through specific cultural institutions such as education, the family, religion, law, culture and communications systems. Women have not only been kept outside of some of these institutions of power, but have

also been defined as different and as 'other' within them. Thus Bakhtin's notion of ideology is not complex enough to help us to interpret or change these conditions.

Bakhtin nevertheless celebrated difference, which he described in terms of boundaries and outsideness. One might even argue that in his artistic and political milieu of the early 1920s he was astute to value difference at all. But as scholars such as Caryl Emerson have repeatedly observed, Bakhtin cared about the differences we choose to work on, not those that define us in more essential ways (1997). Clearly, from a feminist perspective, Bakhtin's idea of outsideness is politically naive. It does not compel examination of power dynamics, or the way sex and gender differences are ideologically inscribed in diverse cultures. In order to understand such processes, feminist and postfeminist analyses are vital.

Gender and class difference are part of a complex ideological system of increasingly hierarchical exclusions. For decades this theme been thoroughly explored in black feminist cultural criticism. Audre Lorde, for instance, repeatedly and vociferously argued for a nuanced appreciation of difference as a source of creativity in our lives (1984). She insists that in Euro-American cultures women have been trained to respond to differences in sex, age, race, class and sexual preference in one of three ways.

First, women may ignore differences as if they don't matter. An example of this is when white middle-class women ignore their differences from white males in positions of institutional power. White women, Lorde suggests, have a wider variety of pretended choices and rewards when they identify with patriarchal power. Second, women may copy what is seen within the dominant cultural group. Such behaviour is obviously most often practised by those who do not have power and want to gain access to it. All women in this situation, whatever their race or ethnicity, try to gain a foothold in male hierarchical institutions by copying appropriate patriarchal behaviour. Third, if both of these moves

fail, women may try to destroy differences and to eliminate those who are different as long as they are subordinate. Sadly, this has all too often been the response of Caucasians to people of colour. Similarly, as lesbians and gay men insist on their rights to public acknowledgment and public voice, individuals and communities have responded with hostility and violence in many cases.

But how can differences among human beings be defined in ways that enable resistance and creative activity for cultural change? It is not sufficient to ignore or even to tolerate difference. Simply to tolerate women's differences denies the way those differences may function creatively. Difference must be 'seen as a fund of necessary polarities between which our creativity can spark like a dialectic' (Lorde 1984: 111). This sentiment is echoed in historian Joan Scott's assertion that we must continually insist on our differences. Difference is a condition of both individual and collective identity, and difference keeps us from fixing our identities. Indeed, history repeatedly illustrates the play of differences, and difference is essential to equality (Scott 1988: 46). It is vital to maintain an attitude of willingness to celebrate difference as a source of both creative visions for the future and the energy to enact those visions.

Careful analyses of issues of identity and difference continue into the twenty-first century. Feminist philosophers and theorists link identity to political subjectivity, knowledge production, diversity, representational strategies and more. Among postmodernist, poststructuralist, postcolonial and postfeminist approaches, there is a strong shared conviction that it is impossible to speak in a unified voice about women, which has led to the messy, ad hoc nature of developments in feminist philosophy over the past decades (Braidotti 2003: 196). Bakhtin would have appreciated that messiness, even though he had no framework for understanding why a strong philosophical focus remains 'on issues of diversity and differences among women' (Braidotti 2003: 202–3). Yet attentiveness to difference in itself does not ensure

that actual differences will be adequately represented in public discourse. Perhaps this is, finally, a task for the contemporary artist and critic.

The artist's ego

My discussion in this chapter of answerability, dialogue, outsideness and difference provides a foundation for a few final reflections here about what I would simply call the 'problem of the artist's ego'. I believe that every artist must ask her- or himself a series of key questions. Who or what *is* an artist? For whom do I make art? What is the source of validation for what I do and make? What about issues of ego? For many artists, fame and public recognition are the sine qua non of studio practice, and occasionally fame leads to a livelihood. Instead of being consumed by the desire for public acclaim, artists may gain much by reflecting about vocation. Is making art a way to boost the ego, earn a living, or is it a vocation or calling in the sense of the Latin *vocatio*? What does it mean to be an artist under the forces of multinational capitalism and an art market that is expanding to include Asia, the Middle East and Africa? An artist might fruitfully ask, what will be my legacy?

It is clear to me that Marina Abramović has thought about such questions. Her performance *The Artist Is Present* invited viewers to open up to the present moment where there is no future and no past, even while confronting discomfort, pain and fear. In a short essay on performance art, Abramović noted that 'there are so many different meditation traditions all around the world that are concerned with this issue: how to get into that moment of *now*'. She ended this essay by invoking artist Bruce Nauman: '[He] always likes to say, "Art is a matter of life and death." It sounds melodramatic, but it is true' (Biesenbach 2010: 211).

Bakhtin would have agreed with both Abramović and Nauman, though his language was not so direct. He was a reticent and private man who had no personal experience of the modern art

world in which egos have such play and prominence. If asked to offer his advice about such matters, I imagine that Bakhtin's answer would echo Caryl Emerson's assessment of his core values: 'Develop the ability or desire to linger over something long enough to know it' (1997: x). This advice – to foster depth of engagement over time – might never lead to the ego aggrandisement that comes from worldly success and renown. Such concerns should be secondary to the artist's vision and vocation.

Chapter 4

The work of art

Located on five acres in rural Scotland close to Edinburgh, Ian Hamilton Finlay's *Little Sparta* consists of plantings, paths, buildings and sculpture, many of which contain inscriptions. The main principle of *Little Sparta* can be described as 'the essential conflict between nature and art, chaos and order, wildness and civilisation' (Sheeler 2003: 81). Indeed, a sense of conflict pervades the place. The site builds on specific themes that Finlay wanted to highlight: Greek and Roman mythologies; war and military engagement; neoclassical references, especially to the French revolution and the so-called reign of terror; and homages to artists and writers of the past. Other than the residence, the largest structure at *Little Sparta* is the Temple of Apollo. As the god of war, Apollo figures prominently in the site. Finlay's Temple to Apollo mixes and transposes cultural meanings. The words inscribed on the entrance to the Temple, 'To Apollo, His Music, His Missiles, His Muses', allude not only to Apollo's arrows, but also to modern weapons such as stealth bombers and laser-guided rockets.

In my view, one of the most impressive pieces at *Little Sparta* contains a quotation from St Just, who condemned the corruption of French culture (Figure 6). Carved by Nicholas Sloan, the 11 massive half-finished stones lie in a field, inscribed with the words 'The Present Order is the Disorder of the Future'. As I stood on these stones, each of which weigh at least a ton, the huge letters were considerably larger than my foot. I experienced an odd disjunction of time, as if the stones carried magical

transformative power. Images of Delacroix's painting *Liberty Leading the People* and David's *Death of Marat* came insistently to mind as I stared into the distant Scottish landscape.

With the insertion of so much historical imagery into the site, Finlay's work can at once amuse, perplex and provoke viewers. In our media context where viewers expect facile and instantaneous understanding of advertising messages, such a demand for slow analysis, even incomprehension, can be challenging. Finlay uses language in his work at *Little Sparta* to signal a gamut of political and cultural ideas. In my experience, the artistic use of verbal language in this garden functions to challenge the viewer's routine perceptions and expectations.

Humans have represented their environments for thousands of years, at least since the painting of now-crumbling walls at Catal Huyuk in Anatolia nearly nine thousand years ago. Even earlier, rock art on North African plateaus depicted features of

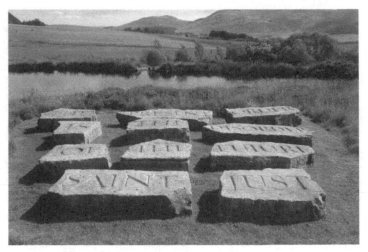

6. Ian Hamilton Finlay, 'The Present Order'
from *Little Sparta*, 1965–present (© 2012).

the landscape such as mountains, rivers and paths. From one point of view, the history of art is the story of human aspiration to represent the experience of place. Certainly this is a broad generalisation and is not true of all art created in all cultures, but even the earliest abstract paintings of the twentieth century, such as Malevich's *Black Square* of 1913–15 or Wassily Kandinsky's 1914 *Small Pleasures,* can be interpreted as depictions of space and place. Further, representation is integral to the perception of a place, though it is difficult to say why we human beings in all cultures and times represent our world in maps, images and other forms (Casey 2002: xiii). For an artist, connection to a place elicits representation of it. Many external factors define the characteristics of a particular place – light, dark and colour, line and dimensionality, vista and view. For these we need representation, which is a product of time.

This chapter takes up the question of what constitutes a work of art by considering examples of land art. Artists and critics often think of a work of art as something that is created or constructed, then finished and presented in the art world. But land art and earlier efforts to represent place in landscape painting traditions present an opportunity to see the potential for interpreting particular concepts in Mikhail Bakhtin's works, such as his reflections about time and the chronotope, prosaics and the relevance of his ideas about literary genres to the visual arts. Here I do not mean to imply that Bakhtin's ideas are less relevant to other forms of art and art-making practices. I hope that more scholars will be inspired to examine the usefulness of these ideas in other contexts.

Time and the chronotope

Bakhtin's writing about time is interspersed throughout his essays and books on literary genres and theories of the novel. In his essay 'The Bildungsroman', he speculated about how time is a process made visible in specific localities or landscapes that must

be understood in terms of historical time (1986: 10–59). According to Bakhtin, 'The ability to *see time*, to *read time*, in the spatial whole of the world...is the ability to read in everything signs that show time in its course, beginning with nature and ending with human customs and ideas' (1986: 25). Time, therefore, is given shape by trees, livestock, visible signs of human aging, and by the traces of human creativity in environments of all kinds, including works of art. As he wrote, 'The artist perceives in them [these vestiges of human creativity] the most complex designs of people, generations, epochs, nations, and social and class groups' (1986: 25). Bakhtin thus highlights the 'seeing eye', which is connected to 'concrete sensory signs and the living figurative word' (1986: 25). Using Goethe as his model in this essay, Bakhtin further muses about how 'everywhere here the *seeing eye* seeks and finds *time* – development, emergence, and history' (1986: 29). For Bakhtin, the past is creative in the present through its effects. In several fragments, Bakhtin muses: 'The seeing eye saturates landscape with time – creative, historically productive time'. The land needs history since the land is 'illuminated' by human actions and historical events. Analogously, history must be 'localised in terrestrial space', locale or place (1986: 34). Nothing is static because all things increase, decrease and constantly pulsate. Even mountains, which an ordinary observer might conclude are essentially static and immutable, actually change, oscillate and even create weather (1986: 29–30).

Although he did not create a typology of time, Bakhtin wrote about 'small time' and 'great time', concepts that are related to Fernand Braudel's concept of *longue dureé*. In Braudel's formulation, history cannot be reduced to a system or single framework because it is the product of endless interconnected actions of human beings in diverse situations. Historians who seek to tell the stories of history as dramatic narratives of great men therefore tend to overlook ordinary elements of daily life, which do not change dramatically. While recognising that sudden

changes are possible, historians of Braudel's Annales School therefore focused on the 'long duration' or long-term changes over time, rather than dramatic events in individual biographies (Braudel 1980: 6–54).

A work of art considered in 'small time' would be examined in relation to its present context as well as the recent past and foreseeable future, while the category of 'great time' is more useful for understanding cultural artifacts and whole cultures. 'Great time' means the 'infinite and unfinalised dialogue in which no meaning dies' (Bakhtin 1986: 169). By these definitions, the canonical works of art history exist in such great time, while the artworks created by contemporary artists in their studios inhabit small time. Consider, for instance, the traditions of Orthodox icon writing in Byzantine, Russian and Greek cultures, or the *thangka* painting traditions of the Himalayan region, both of which have been ongoing for more than 1000 years. Rembrandt's self-portraits, discussed in the last chapter, have taken their place in great time, as have well-studied Inca and Aztec sites such as Machu Pichu and Templo Major. However, for Bakhtin the ability to discern how an artwork exists in time is not based on a grand historical metanarrative but on a nuanced interpretation of outsideness and the chronotope.

As discussed earlier, Bakhtin developed the concept of outsideness in order to emphasise how both self and other are knowable only because of the boundaries that frame and define the self over against others and the world. This is especially clear when one considers both historical traditions and contemporary examples of landscape painting, photography and sculpture. In order to understand fully the effects of urbanisation and globalisation, for example, we need an other, an outside vantage point that functions both to demonstrate what cities do and do not offer. Artists who engage the land by painting rural environments, country and city life, and wilderness provide that outside standpoint.

Where dialogue describes the process and practice of communication and relationship among selves or objects, the concept of the chronotope describes the time–space nexus in which life exists and creativity is possible. As Bakhtin explored in his long essay 'Forms of Time and of the Chronotope' (Bakhtin 1981a: 84–258), there is no experience outside of space and time, both of which always change. Subjectivity dictates that an artist create objects that are always constituted differently. All conditions of experience are determined by space and time, which are themselves variable, and this means that every artwork exists in a unique chronotope. Within any situation there can be many different chronotopes, values and beliefs, and these derive from actual social relations.

An example of Bakhtin's own sustained interpretation of chronotopes and chronotopic motifs can be seen in his 1965 study of Rabelais, *Rabelais and His World*, which was first translated and published in English in 1968. In this book he moved away from moralistic nineteenth-century readings of carnival and the grotesque and toward a reconstruction of the folk culture of carnivalesque laughter. He had explored such themes in other essays, but in *Rabelais and His World* carnival became an example of a genre type. In carnival and in folk culture official institutions and definitions of the sacred are intermittently transcended or inverted. Bakhtin's reading of Rabelais cannot be understood solely as an historical study of carnival, however, since Bakhtin sought to show that the world is a place where the physical drama of the body (through birth, sex, eating, drinking, evacuation and death) is played out. In analysing phenomena such as laughter, masks, grotesque images of the body and various forms of debasement, Bakhtin created an encyclopedia of chronotopic motifs and of folk culture more generally, showing that the body is actually the foundation of society and of our relationships to nature. Although not pertinent to land art per se, Bakhtin's reflections about such themes have been useful to

scholars analysing historical artworks, such as Giotto's *Last Judgment* (Miles 1989: 147–50), Diane Arbus' modern photography (Budick 1997) and the work of Ukrainian artist Ilya Kabakov (Tupitsyn 1996).

How then do we gain understanding of a chronotope different from our own? Unavoidably, critics and historians of art must wrestle with this problem. If a work of art is only understood in relation to the local and particular, then it will be of narrow artistic or scholarly significance. Thus an art historian or critic (and the viewer in general) must recognise not only her own chronotope, but also the unique chronotopes of the artist and object. Only then can one give an object a place in great time. An historian therefore straddles two chronotopes – his own and the historical context of the work.

Examples of the interplay of chronotopes abound in Finlay's *Little Sparta*, particularly around references to war. 'Nuclear Sail' is a small, black granite monolith that emerges from the ground like the top of a nuclear-powered submarine. 'Nautilus' is a small-scale model of another submarine. There are also many references to World War II. For example, on one stele code names given to Japanese aircraft by the Americans are inscribed with the inclusive dates of their operation. With such pieces we are constantly reminded of the wars of the last century and the fragility of life on the planet.

In relation to the French Revolution Finlay memorialises particular individuals, such as Rousseau, Corot, Robespierre and St Just, with inscriptions of their names and sayings attributed to them. His work combines references to the Terror, during which many citizens were guillotined and murdered, with a pastoral sensibility and neoclassical nostalgia for Roman republican honour. This evocation of historical chronotopes links us to the cultural past. In his stone inscriptions and sculptures Finlay also memorialises artists and writers such as Albrecht Dürer, Claude Lorrain and Martin Heidegger. I was inspired by the use of both

Latin and English on some of these stones because it heightened their accessibility, but it is also worth noting that Finlay used Latin not only to lend dignity to the stones, but also to obscure the meanings of words and phrases.

Finlay's work is full of the elements of crossword solving, conundrum and riddle. In *Little Sparta* the accessibility of the written texts depends on the visitor's imagination and knowledge. For instance, in the undated small book *Sentences*, which I examined at Inverleith House in the Royal Botanic Garden in Edinburgh, Finlay wrote, 'Inscriptions are the best part of garden, as decals are the best part of Airfix kits'. Initially, I did not know what this meant. Then, wandering down Leith Walk in Edinburgh one evening, I saw Airfix model aircraft kits in a store window. The metaphor is fitting, given the main themes of *Little Sparta*. At that moment my chronotope coincided with Finlay's.

Prosaics

The term 'prosaics' is highly suggestive for discussing land art. Prosaics refers first to the comprehensive theory of literature that Bakhtin developed, a theory that privileges prose and the novel. But second, and more pertinent here, prosaics is a way of thinking that foregrounds the everyday and ordinary. Bakhtin shared this latter sense with other writers and philosophers of the nineteenth and twentieth centuries, such as Leo Tolstoy, Ludwig Wittgenstein, Gregory Bateson and Fernand Braudel (Morson and Emerson 1990: 15). What interests me here is the way Bakhtin emphasised that wholeness and integrity of the self are not given, but that they are always a matter of work, a project to be undertaken in everyday life. One of Finlay's most famous statements reflects this prosaic quality of activity in daily life: 'Gardening activity,' he stated, 'is of five kinds, namely, sowing, planting, fixing, placing, maintaining. In so far as gardening is an Art, all these may be taken under the one head, composing' (Sheeler 2003: 17).

In writing moral philosophy Bakhtin repeatedly made the connection between thought, action and the prosaic. 'Every thought of mine,' he wrote, 'is an act or deed that I perform – my own individually answerable act or deed'. One's life involves the uninterrupted performing of such acts, which result in the fact that 'my entire life as a whole can be considered as a single complex act or deed' (1993: 3). Bakhtin repeatedly affirms that through our acts we are answerable and responsible; there is no 'alibi'. Our uniqueness and particularity constitute our 'non-alibi in Being' (1993: 40). As one of Bakhtin's translators described this term, we cannot be relieved of our responsibility for an act by an alibi – that is, 'by claiming to have been elsewhere than at the place of commission' (1993: 95). To speak of prosaics is thus a way to acknowledge that creating an integrated life takes a lifetime. This process may never be completed, but is nevertheless a moral responsibility (Morson and Emerson 1990: 31).

I have for many years been inspired by land art that highlights transience and impermanence, as well as a commitment to working primarily with materials in nature. Hamish Fulton's walks can be interpreted as profound dialogues with the physical environment that are carried out as part of everyday life. This work has little lasting impact on the land, but brings consciousness to the land itself and to human interaction in the environment. As a self-proclaimed 'walking artist', Fulton creates works that are stridently anticommodity, yet he also produces wall texts for exhibition and books for distribution that reflect his various walks. As he famously said, 'An artwork may be purchased but a walk cannot be sold'.[1] Since his 1973 walk from northern Scotland to Land's End in southern England, Fulton's walking has been the essence of his artistic practice. Although he keeps journals and documents his walks with photographs, he differs from land artists such as Richard Long insofar as he leaves no trace of his presence in the landscape. Of all of his walks, I find most moving those that are documented in his book *Kora* (2008). The word *kora*

means circumambulation of a sacred place. The book documents Fulton's visit to Tibet in 2007, where he walked around Mt. Kailash in a gesture that echoes traditional Buddhist pilgrimage practice. In 2008 he made a series of 49 small paintings that commemorated this journey, each with a text that ends by invoking the cold wind and sleet of the Drolma Pass and the energy of a Buddhist nun whom he followed. Besides illustrating 14 of these paintings, *Kora* highlights the long-standing Sino-Tibetan conflict, including the Chinese invasion of Tibet in 1959 and the March 2008 Tibetan protests. Such work takes us out of the prosaic and into historical and ethical questions about justice and freedom.

Although Fulton denies that his work is part of the tradition of land art, his walks reflect a strong anti-industrial and antiurban aesthetic, as well as an attempt to escape to some degree from the gallery-museum and art-world systems. Because much of the work is transitory, many of the examples do not last, and therefore this land art as a category seems to disappear. In this sense, such works foreground the everyday, mundane, *prosaic*, qualities of walking and simply sitting in the landscape. It is encouraging to me that an increasing number of contemporary artists focus precisely on this terrain.

Genre

Bakhtin sought to demonstrate the intrinsic connectedness of temporal and spatial relationships in literature through discussions of literary genre. Specifically, he developed the concept of the chronotope to define how the novel is distinct from other genres such as the lyric, tragedy, myth, confession and biography. For instance, the epic (Homer's *Iliad* and *Odyssey*, or the Gilgamesh story) is characterised by a chronotope that values a national heroic past. It remains rooted in tradition, and temporal distance separates it from the present. By contrast, the novel, with its worlds in the making, is usually rooted in more present experience and multilayered consciousness. Thus the

chronotope of the novel expresses an open-ended relationship to the future that is lacking in the epic.

This question of genre is thought provoking in relation to the visual arts. The term 'genre' was used mostly within European painting traditions from the Renaissance through the nineteenth century. Critics analysed the painting of these centuries in terms of whether they depicted history, portraits, everyday life (a special category of genre painting), landscape, animals or still life. In general, genre was differentiated from style, media and subject matter. However, in the late twentieth century and continuing into the present, many references can be found to 'new genres', which include land art, installation and performance, film, sound and digital arts, as well as other hybrid emerging art forms. Such art tends to begin with concepts and move toward the most appropriate form or media for exploring the artist's ideas.

I see connections between the evolution of land art (a new genre) to landscape painting traditions of the seventeenth to nineteenth centuries (a traditional genre). Prior to the widespread development of these traditions, renderings of parks, houses, estates and castles may be called the first landscape or garden paintings. Garden paintings not only became symbols of possession but were created as portraits of beloved places in several modes, as emblems and panoramas. Their viewpoints were cartographic and seasonal, and included antinaturalistic elements such as cartouches (Strong 2000). French and Italian renderings of houses, villas and estates were among the first representations of the land. From the seventeenth century, the tradition of park or estate painting began to develop in England and in the Netherlands. In Britain such paintings became a strong national phenomenon (Harris 1985). Dutch artists depicted the rise of the mercantile class and how humans created or altered the landscape. For example, Meindert Hobbema's 1689 *Avenue at Middelharnis* shows the peaceful orderly beauty of the land as it was constructed by humans.

Other European and American landscape traditions of this period can be described more generally as vacillating between depictions of the tamed and heroic landscape. John Constable's studies of Hampstead Heath provide examples of the tamed landscape where human intervention is everywhere apparent. His widely known 1821 *Hay Wain* shows Constable's respect for location and his interest in the conditions of light, atmosphere and weather. The heroic landscape can be seen especially in the work of nineteenth-century Hudson River painters such as Asher B. Durand. Durand's paintings *Kindred Spirits* (1849) and *Progress* (1850) depict the grandeur and majesty of the landscape, but with the added imprint of industrialisation and human settlement. Taking the land itself and the relationship of humans to the land as their subject matter, painters of the modern period vividly rendered the landscape in its multifarious forms.

By the mid-twentieth century, however, artists had begun to engage the environment more directly. This new genre of land art is known by several names: site-specific installation, environmental or ecological art, earthworks and what Amy Dempsey has aptly called 'destination art' in her book of that title (2006). Herbert Bayer is often credited with creating the first earthwork, his 1955 *Grass Mound* at the Aspen Art Institute in Aspen, Colorado. There are many reasons for this move away from the easel and the studio in the twentieth century that are linked to wider social and cultural processes. Suffice it to say that many artists were not only seeking an escape from traditional painting and sculpture, but they also returned to ancient practices related to megalithic monuments in England, Ireland and Scotland – sites such as Stonehenge, the Poulnabrone dolmen and the Ring of Brodgar. In a curious contradiction, the dematerialisation of art led to the material or physical matter of art assuming primacy in some artists' work.

There are certainly many ways to approach land art. One can consider its symbolism and what is involved in making it. One

can examine issues regarding its accessibility and the complex relationship between creator, object and viewer that is set up by the work. A significant aspect of this kind of art is that it challenges the commodity status of art because it cannot easily be bought and sold. Gender, race and class issues are especially pertinent for these kinds of analyses. And I am convinced that Bakhtin's theories of the novel are relevant here.

Writing about the historical typology of the novel, Bakhtin defined numerous major types, including the travel novel, novel of ordeal, biographical novels, adventure novel, romances, and the novel of education or emergence (1986: 10–59). These types are primarily determined by plot, conceptions of the world and particular types of composition. He linked Dostoevsky, Goethe and Rabelais to three major theories of the novel, all of which embody 'prosaic intelligence', 'prosaic vision' and 'prosaic wisdom' (Morson and Emerson 1990: 300–5, 308). The first theory is based on special uses of language, what he called 'dialogised heteroglossia'. Dostoevsky, he thought, was an expert at such multivoiced use of speech and language. The second theory is based on genres as depicting distinct types of historical time, social space and moral activity. Goethe, Bakhtin claimed, was a master of differentiated use of time and space, or chronotopes. The third theory is based on ideas about carnival. Bakhtin saw unique explorations of carnivalesque parody in Rabelais.

In Ian Hamilton Finlay's *Little Sparta* and in Morris Graves's sustained work on several sites, most notably *The Lake*, I see examples of land art that can be analysed in terms of Bakhtin's second theory of the novel. The characteristics mentioned in this theory – historical time, social space and moral activity, along with fragmentary reflections on language itself – are further delineated in Bakhtin's writing with a number of concepts, including emergence or becoming, creative necessity and the fullness of time, seeing time, presentness, and the surplus of humanness.[2] Before comparing the two sites using these ideas,

let me provide a few words about Morris Graves, whose work is not as widely known as that of Finlay.

I first encountered the art of Morris Graves as a young undergraduate at the University of Oregon, where his drawings, paintings and sculptures were on display in the university museum. His unique iconographic and symbolic language, his use of mythological imagery, and his overt interest in Hindu and Buddhist forms such as mandalas and *thangkas* captivated me. I knew from a young age that artists such as Graves and Mark Tobey had looked westward, across the Pacific toward Asia, for their inspiration. In particular, Graves's development of a personal symbolic language, with forms such as birds, trees, snakes and other elements drawn from nature, had a great impact as I was developing my own visual vocabulary.

Besides my interest in Morris Graves's imagery, I feel deeply connected to his profound commitment to place. This was expressed, though barely acknowledged in the voluminous writings about him, in his engagement at four sites where he lived from 1939 until his death in 2001. Graves moved to The Rock on Fidalgo Island near Seattle in 1939, and lived there for eight years. In 1947 he settled for 11 years at Careladen near Edmonds, Washington. Graves then moved for nearly eight years to Woodtown Manor, an eighteenth-century manor house in County Dublin, Ireland, which he renamed Woodway Park. Finally, in 1965 he purchased over 100 acres in northern California, where he lived for 36 years until his death. A lake was created there during an earthquake in 1700, when a bowl was formed and eventually filled with water from the local watershed. Graves removed debris from the lake, carved out a trail around it, and created a unique contemplative ambience on the site. Even though he had limited financial resources, Graves devoted extraordinary energy to creating these unique aesthetic environments that were known primarily to his friends during his life. Few of the scholars who have written about Graves's

work have commented on his engagement with specific places – The Rock, Careladen, Woodtown Manor and The Lake – yet these are among his least well-known but most significant works of art (Ament 2002).

While one might apply Bakhtin's idea of emergence to any work of art, I see it as especially pertinent to Morris Graves's commitment to these specific places. The concept of emergence or becoming sometimes refers to cyclical processes that repeat themselves in every human life. For instance, we know that all individuals go through processes of birth to death, including some combination of accidents, old age and illness. Through these experiences individuals develop their identity, and certain types of novels show how this occurs in an historical and social context. But emergence can also occur without these cyclic qualities, through individual, unrepeatable changes. According to Bakhtin, emergence is 'the result of the entire totality of changing life circumstances and event, activity and work'. A person's destiny is created, along with a person's character, through unique processes of becoming (1986: 22). Living at *The Lake* for several weeks in 2006 during a residency sponsored by Robert and Desirée Yarber of the Morris Graves Foundation, I had a unique opportunity to experience first-hand its subtle beauty and serenity, which emerged from decades of dedicated labour.

Comparing *Little Sparta* and *The Lake* allows me to highlight some of the unique qualities of each site using Bakhtin's theory of the novel. Little has been written about Graves's site work, while *Little Sparta* is considered a major artwork of the twentieth century in Europe.[3] Both men began their projects in the mid-1960s and carried on until they died, Graves in 2001 at age 91, Finlay in 2006 at 81. *Little Sparta* is smaller than *The Lake* and more developed since Finlay worked with at least 30 artisans, craftspeople and designers. Sue Swan and Pia Simig collaborated most closely with him from the 1960s until his death in 2006, and Ralph Irving worked as a gardener on the site for many years.

Robert Yarber began working with Morris Graves in 1974 and has remained there since Graves's death.

Located on hilly terrain about five miles from the Pacific Ocean, the centre of *The Lake* is a series of buildings that surround a pristine lake. Paths lead in all directions: one circles the lake; others lead further into the grand fir, spruce and redwood forests. Still others direct one to a stone labyrinth within the trees and to a pentagonal platform with a view of the Pacific Ocean. Whereas *Little Sparta* relies on texts and inscriptions, the few texts at *The Lake* are primarily on small wooden signs that indicate direction along its paths.

Bakhtin's fragmentary reflections about language, written during the last years of his life, are relevant to the use of text on the land, especially at *Little Sparta*. Published after he died in *Speech Genres and Other Late Essays*, 'The Problem of the Text' was actually a series of notebook entries. These reflections show Bakhtin's mind at work on problems that are difficult to elucidate. In one especially evocative paragraph, he wrote: 'Epigraphy. The problem of the genres of ancient inscriptions. The author and the addressee of the inscriptions ... Grave inscriptions ... The deceased addressing the living passersby...Ideas about the magicality of the word' (1986: 115). Yes, I might say to Bakhtin, ancient inscriptions were written in many genres, with various authors and audiences. Grave inscriptions definitely address the one who stops to look at a stone in a cemetery. And *magicality*? Many of the carved texts at *Little Sparta* carry this unique quality that exceeds literal interpretation, and this is the experience I tried to describe as I stood on each of the massive stones in Figure 6.

Both sites contain many paths that traverse the terrain, and both are maintained with tremendous care to create aesthetically pleasing environments. The extent and type of path are related to the size of each site. Finlay and his collaborators created many stone and brick paths as well as mown areas so that the entire site seems dense and tamed. Graves and Yarber, however, cut

wide swaths through the forest and narrow paths around the lake in order to make some of the large site accessible by foot. But the land as a whole remains wild – forbidding, uncultivated and unadorned. Walking these paths, one can truly appreciate the expansiveness and majesty of the natural world.

Garden furniture such as benches and trellises adorn both sites. At *The Lake* my favourite benches were those that allowed rest among the ancient giant trees. Small bridges have been built over streams and waterways. Both sites contain altars or sacred places. Historically, classical altars tended to be dedicated to particular gods, while Christian altars honoured God, Jesus, Mary or the saints. *Little Sparta* contains a number of sculptures that allude to these traditions. A simplified aircraft carrier, made of stone, suggests an altar, although its inscription 'II 1019' is obscure. These numbers actually refer to words of the Stoic philosopher Chrysippus, who wrote that altars provide evidence of the gods. An altar is a particular kind of social space that can carry what Bakhtin called 'creative necessity'. He believed that 'human creativity has its own internal law. It must be human... *necessary*, consistent, and true, like nature' (1986: 39). Bakhtin used this phrase in opposition to an understanding of creativity rooted in inspiration or utopian ideals where arbitrary, fabricated or abstract fantasies would dominate (Morson and Emerson 1990: 414). At *The Lake* Robert Yarber planted a grove of redwoods, an echo of an ancient sacred grove – a Greek *temenos* or Celtic *fidnemed*. A profound sense of stillness and solitude characterises this space. For Bakhtin, creativity must be rooted in real actions carried out by real people in daily life. This activity is precisely what I have been describing at both sites.

Many dualities characterise *Little Sparta*. Tenderness is juxtaposed with challenging content, intellectual references sometimes compete with emotional affect, and serious intent is balanced by the playful. By contrast, *The Lake* is a place of tremendous silence, offering viewer and visitor the possibility

of integration. Observing the placid lake in the early foggy morning, massive trees perfectly reflected in its face, or later on a windy afternoon to wonder at the brilliant blue and silver sparkles emanating from the surface: these experiences cannot be replicated. *Little Sparta* teaches about density and intimate scale, about the richness and possibility of language on a site. *The Lake* teaches about grandeur and spaciousness, including the spaciousness of consciousness itself, and about the power of the understated and wild. Both sites are contemplative and restorative places. At both sites one feels a sense of being away, being in a different world, and of compatibility within that world. The environments support the visitor and do not demand a particular focus of attention, yet they encourage us to look within. Such places may become restorative as well as contemplative, but there is no recipe for creating them (Krinke 2005). One may experience a heightened awareness of distance and time: of Bakhtin's small time – personal bodily time, and of great time – being part of history and cycles of the cosmos.

For the artist, there are many strategies for promoting contemplation in order to change one's perception, thereby creating another kind of experience. These strategies can include the use of enclosure, so vividly exemplified in medieval cloisters and *karesansui* gardens such as Ryoanji Zen Temple in Kyoto, Japan. Finlay and his collaborators created buildings and outdoor enclosures that invite the viewer to linger and rest. Walking can be used as a means to shift awareness, thereby linking the experience to ritual performance, as I experienced both at *Little Sparta* and *The Lake*. Seating at *The Lake*, such as the pentagonal bench, allows one to look out at the Pacific Ocean, and the many benches at *Little Sparta* increase the potential for meditative experience. The fact that access to both sites is restricted also heightens their sense of uniqueness.

I conclude this chapter on the work of art with four terms in Bakhtin's writing that show how time, space and place are

interrelated. With the terms 'the fullness of time', 'seeing time', 'presentness' and the 'surplus of humanness', Bakhtin specifies how the chronotope, prosaics and genre intermingle. Since humans build places and create objects, Bakhtin believed that they should not only express a merging of the past with the present, but also a sense of the creative and active nature of time – that the past would be visible *in* the present and *of* the present. This awareness of time would be linked to the future as well, so that a true feeling for the necessity and fullness of time would be awakened (Bakhtin 1986: 41–42). In his essay 'Epic and Novel', Bakhtin further defined the sense of time as it is lived with the idea of 'presentness' (1981a: 30). The present can never be whole, but is always inconclusive, demanding continuation and moving into the future. The present must therefore be open to multiple possible futures; herein lies the potential of the artist's creativity. Thus the 'fullness of time' is a way of referring to the interconnections of past, present and future. Related to the idea of presentness, Bakhtin wrote of the 'surplus of humanness' (1981a: 37). Because the present is always inconclusive, there will always be both unrealised potential and unrealised demands in a person's life. This unrealised surplus of humanness expresses a need for the future and a place where that future will unfold. Artists such as Ian Hamilton Finlay, Morris Graves and Hamish Fulton demonstrate how working on and exploring particular sites, *in space and place*, can help us to realise our potential and create the future.

Chapter 5

An interpretive study: Claude Monet

My first glimpse of Monet's 1884 *Cap Martin, near Menton* (Figure 7) occurred as scholar John House and I were walking slowly through galleries in the Kimbell Art Museum in Fort Worth, Texas. He was directing my examination of several paintings from Monet's stay in Bordighera, Italy. Looking at individual paintings from the artist's 'Valley of Sasso' series, at groves of olive trees, and at a few palm trees, I was stunned. I had gazed indifferently at Monet's paintings many times in museums in Europe and the USA; but this time, under Professor House's direction, I used reading glasses to examine the colour and brushwork, just a couple of inches from the surface of each painting. I knew, of course, that this artist was a master at using saturated colour to produce startling chromatic contrasts that reflected subtle changes in light and atmosphere. I already knew that Impressionist brushwork was considered revolutionary, even scandalous, at the time. Most artists and art historians have experienced the profound pleasure of actually *seeing* what an artist was doing for the first time, and so it was for me on that day. Speechless, I moved from painting to painting with new eyes.

Then, turning into a gallery with paintings from Monet's trip from Bordighera to Monte Carlo, I paused. Several paintings featured a red road near Menton, one with a tiny figure dwarfed by the 'Dog Head' rock formation that dominates the landscape above the city. But there were two smallish paintings, each about 26 inches by 32 inches, which grabbed my attention. *Cap Martin,*

near Menton (Figure 7) uses warmer colours than its companion, which depicts the same scene. With turbulent clouds, mountain, city, sea in the background, trees and rocks nearby, the foreground is dominated by a road that flows like a river. Although it seems strange in retrospect, Monet's brushstrokes created a kinesthetic sense of actually moving along this road. In that moment Monet's road became a metaphor for *path*, the unique path that each of us must walk in this life. For me *Cap Martin, near Menton* was a powerful, visceral experience of being thrust into a particular time and place, a *chronotope*, by a work of art. I was not curious about the distant town or the nearby rocks that led to the sea; I only wanted to follow that road and find out where it might lead.

This chapter is structured as a conversation between Mikhail Bakhtin's ideas and Monet's paintings from three journeys to the

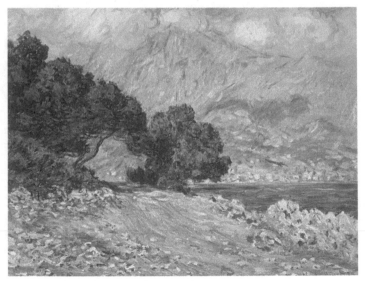

7. Claude Monet, *Cap Martin, near Menton* (1884), Photograph © 2012.

Mediterranean between 1884 and 1908. In particular, Bakhtin's philosophical language offers a new set of questions with which to query Monet's painting. By focusing on concepts such as answerability, dialogue and polyphony; outsideness and the chronotope; and issues of finish and unfinalisability in relation to Monet's Mediterranean paintings, I hope to broaden the scope of the conversation about Monet's contribution to the history of painting and Bakhtin's contribution to interpreting visual art. Bakhtin's concepts, which are slowly finding their way into the vocabulary of art historians and critics, may well offer ways to articulate what Impressionist, as well as later Postimpressionist and Symbolist, artists were after.

Monet overview

Monet was born in 1840. His career as a painter included representing urban and human-made landscapes, figure painting, still life and unsullied nature, but from 1870, the year he married Camille, he restricted his work to landscape. In 1878 Ernest and Alice Hoschedé and their six children moved in with Claude and Camille Monet and their two sons in Vétheuil. Both families faced serious financial stresses. Monet's first wife, Camille, died in 1879. He distanced himself from his artistic colleagues by the time of the sixth Impressionist group exhibition in 1881, preferring to work in isolation. Following the death of Ernest Hoschedé, Monet, Alice and her children moved to Giverny in 1883. By the mid-1880s, Monet's financial fortunes had begun to shift as his work was exhibited and bought. Alice died in 1911. Monet died in 1926 following health problems and more than a decade of cataracts and declining eyesight.

Monet's first Mediterranean trip was in 1883–84, to Bordighera on the Italian Riviera for ten weeks. He took this trip on impulse with Renoir and concentrated on two motifs: the sea and Mediterranean light. Other themes emerged as well, including exotic aspects of the region such as palm trees, the

Moreno garden, views of the mountains surrounding Bordighera, and later the area around Monte Carlo. Evidently, though he initiated his three-month stay with Renoir, he decided early on not to rely on Renoir's knowledge of Italy. 'I have always worked,' Monet wrote, 'far better in solitude and after my own impressions only…It is always a bad thing to be working alongside someone else' (Pissarro 1997: 28). With such statements Monet gives the impression of self-sufficiency, but the truth is actually far from this since he depended heavily upon his correspondence with critics and with Alice Hoschedé, his companion of nearly twenty years. From Bordighera Monet went on to Menton and Monte Carlo. The two places represented distinctive visual dynamics. Bordighera was full of detail and exotic diversity, while Monaco seemed a place full of 'readymade pictures', as he wrote to Alice (Pissarro 1997: 36).

The second journey took place in 1888, when Monet went to Antibes. It is not clear why Monet took this trip. He spent most of his time alone, choosing as his main theme the relationship between what is paintable and what must remain unpaintable (Pissarro 1997: 42). In letters to Alice, Theo van Gogh and others, he wrestled with several problems: his serial procedure of painting more than one picture of a subject from different vantage points and under differing circumstances; the whole issue of the relative incompleteness of his work; and how his happiness was linked to his identity as an artist. As he wrote to Alice, 'I do not know where I am going; one day, I think I am producing masterpieces, and the next day, nothing is left…I am struggling without getting any further. I think I am seeking the impossible' (Pissarro 1997: 44). Plagued by weather and by money worries, he nevertheless completed 39 paintings during this second visit to the Mediterranean.

The third trip was in 1908, to Venice. By this trip Monet was heading a considerable business that included international sales of his paintings, especially in the United States. He may

have worried whether he could meet the challenges of Venice, where the traditions of the pictorial and the picturesque had been played out for centuries. Few letters are extant from this trip since Alice accompanied him. During this last trip to Italy, he altered his original serial practice.

In Bordighera Monet had painted from slightly different vantage points, noting in the paintings objective differences such as weather, lighting, the sea and vegetation. Formal differences such as size, finish and colour, as well as subjective differences in mood were also his focus. His decision to record the effects of light on the same motif at different times of day and in different weather was part of his effort to find a principle of consistency for pictorial art elsewhere than in the precedents of the past (Greenberg 1985: 378). But in Venice he instead painted in the same place at the same time each day. Monet began to try new approaches, searching to eliminate time as a variable in his paintings, so that he could concentrate solely on the interrelationship of atmosphere, light and colour.

Approximately 125 paintings survive from his three sojourns to the Mediterranean. Most of these latter works were small enough that he could pack the canvases under his arm, as he set out for the villa garden, the shore or the canal. Over 2,000 of Monet's paintings still exist in museums and private collections.

Claude Monet's name cannot be separated from Impressionism more generally.[1] Impressionism evolved in France as a democratic movement in the 1860s and went through several phases. It entered a more public and mature but still scandalous phase in the 1870s. By the 1880s Impressionism had become an aesthetic force, though some critics still derided the art. Defining Impressionism has occupied scholars for well over a century, but in 1866 Paul Cézanne articulated two of the important themes that came to define the artists' position: the artist's inalienable individuality, and the right to be seen by the public (Pissarro 1987: 17–18). In order to categorise what is genuinely 'Impressionist',

historians and critics have examined particular artists' social groups, subject matter, style or technique, and the artistic goal or purpose of their work. The artists' use of technical devices such as bright colour and accentuated brushwork were the characteristic means of applying the theory of the 'impression', which gave these painters their name (Shiff 1986: 69–70). Impressionism was based on the sharing of ideas, techniques, compositional recipes and even the act of painting itself, since a number of the artists worked together, even painting the same scenes in nature. A common style evolved for a time, but artists such as Monet eventually moved away from Impressionist circles.

I do not mean to imply here that the power of Impressionism was an 'unthinking form of naturalism', as Robert L. Herbert put it. Rather, the movement was born of adversities and miscomprehension within the larger art world of the time, and those technical devices functioned in genuinely subversive ways. These artists' devotion to the present moment shocked the artistic establishment and the public, undermining both accepted concepts of art and the organisation of art exhibitions (Herbert in Lewis 2007: 23–24).

Although I have lectured in art history courses on Claude Monet and other Impressionists for over 20 years, I have never felt the kind of passion toward his work that I feel, for example, toward the early twentieth-century Russian avant-garde or certain strains of contemporary art that wrestle with the impact of digital technologies. For years I have been convinced that it is very hard to see Monet's prodigious production outside of its commodification. If, in the twenty-first century, an artist's work is well known and well circulated through T-shirts, baseball caps, cookbooks, wrapping paper and the like, what happens when we look at the 'real thing'?

Perhaps we should take heed of Émile Zola's eclectic taste, reflected in a statement about Édouard Manet: 'I accept all works of art in the same way, as manifestations of human genius.

And they interest me almost equally, they all possess genuine beauty: life, life in its thousand expressions, ever changing, ever new' (Shiff 1986: 72). Zola later evaluated Monet's technical accomplishments and concluded that Monet's haste to produce and sell his paintings resulted in a kind of technical failure (Shiff 1986: 76). Notwithstanding such assessments from his contemporaries, Monet's paintings have proven themselves to have remarkable staying power in the public imagination, and his art continues to offer considerable visual pleasure.

Given this legacy, is it possible to open another kind of window onto Monet's painting? While I refer to particular paintings in this chapter, I mainly hope to engage the reader's sense of new interpretive possibilities for art that may be quite familiar. Usually scholars engage in a range of approaches to Monet's art: they continue to analyse the formal power of his painting; they examine the critical reception and the formative role of critics in shaping Monet's popularity; or they may explore the curious lack of markers in his work of the increasing industrialisation and effects of World War I that he witnessed during his mature years. Occasionally his paintings have been interpreted in political terms, although they do not incorporate obvious symbols, as in the war paintings of Otto Dix. For instance, his ten weeping willow paintings from 1918–19 were evidently his response to the mass tragedy of the Great War.[2] Certainly Monet's work evolved against the artistic and political crises of nineteenth-century France, which included the artist's escalating ambition, the highly competitive art market, and rising French nationalism of the period (Tucker in Lewis 2007: 230). Many of the Impressionists, including Monet, disavowed memory and history in their exaltation of the fleeting moment. History and the urban, political and industrial revolutions were ignored, as were mythology and religion, which had been so important in academic painting of the past.

What I am after in this chapter may be considered more philosophical or theoretical than the approach taken by most

art historians. It is certainly well known that Monet was neither interested in nor articulate about theory. As he wrote to the English art critic Evan Charteris in 1926, 'I have always had a horror of theories; my only merit is to have painted directly from nature, seeking to render my impressions in front of the most fugitive effects' (Broude 1991: 75). His aversion to theory, however, was not shared by all of the Impressionists and Postimpressionists. For example, a comparison of his many letters to those of Camille Pissarro reveals very little about Monet's ideas, while Pissarro wrote much about the social, political and artistic events of his life, along with reflections on the role and nature of art in capitalist society (Spate 1992: 11). Monet's work was simply not impelled by ideas, but instead by empirical experience. This process of encountering and representing empirical reality may not have been theoretically guided for Monet, but it was profoundly dialogical. With this brief overview, I now turn to a more specific dialogue of Monet's Mediterranean paintings with the ideas of Mikhail Bakhtin.

Answerability and dialogue

As discussed in Chapter 3, most of Bakhtin's essays are predicated on the presupposition that the human being is the centre around which all action in the real world, including art, is organised. Therefore, the 'I' and the 'other' are the most fundamental value categories that make creativity viable. Bakhtin identified the mother as the first 'other', but each of us needs others to become persons. In Bakhtin's early essays this sense of the relationship of self and other was expressed with the concept of answerability. Answerability contains the moral imperative that the artist remain engaged with life, that the artist *answer* for life. At every point Bakhtin insisted on obvious ethical aspects of creativity: that, as bodies existing in real time and space, we are responsible, answerable and obligated toward other human beings in and through the creative process.

Monet's Mediterranean paintings contain very few human figures, so it is not obvious from his art to whom he was answerable. However, a 1914 studio photograph not only contains photos of some of Monet's answerable others, but the empty chairs evidence the others upon whom he depended for his public success. His family, especially Alice Hoschedé, and Monet's friends and critics such as Gustave Geffroy and Octave Mirbeau were his primary others, although they were never directly in his work.

To what extent can we speak about answerability in Monet's painting? Answerability, as responsibility or moral obligation toward others, expressed as an individual's concrete response to actual persons in specific situations, does not seem to have been Monet's concern. His attention was focused more on his own commercial success rather than on such specifically ethical concerns. The critic Clement Greenberg, in a now-famous essay of 1957 (1985), characterised Monet as a self-promoter, publicity seeker and shrewd businessman. More recently, Virginia Spate has noted that Monet's art may well have been shaped by his desire for its consumption as luxury objects, which in turn shaped its increasing preciousness (1992: 12).

Like some of his nineteenth-century predecessors, Monet was not concerned with how art was connected with life or with the theoretical implications of his painting practice. Therefore, we may not be able to speak of answerability in the sense that Bakhtin used the term in the early essays. We can, however, acknowledge that there are dialogical aspects to Monet's work, some of which are directly discernible in particular paintings, and others for which we need to know more about his life.

As described in Chapter 3, an artist enters into dialogue (in actual, historical or mythological time) and expresses something about that place, person or event. First, and most specifically, dialogue refers to the fact that every utterance is by nature dialogic: it is always directed at someone in unique circumstances.

Joachim Pissarro has identified several levels of dialogue in Monet's painting that fit within this first definition (1997: 22–24).

At the most fundamental level, Monet engaged in an internal dialogue with the physical world that then formed the motifs for, and pictorial elements in, his paintings. Physical elements such as the light and wind, vegetation, the mountains and sea, and palace facades functioned as his interlocutors. Although Bakhtin did not really recognise the physical environment as a possible other, Monet clearly did. Paintings such as his *Grand Canal* series of 1908, with their glorious colour variations of sea, sky and architecture, express this sensibility.

Monet also engaged in a dialogue with the past, especially with those artists who dealt with the Mediterranean, as well as with his contemporaries such as Auguste Renoir, Édouard Manet, Berthe Morisot, James Whistler and John Singer Sargent, among others. His dialogue with Alice Hoschedé, through letters written during his first two visits to Italy and through her life and travel with him, was extremely important. While Alice may have been his primary dialogical other, we must not underestimate the formative effect of Monet's dialogue with his critics and dealers. With the help of critics such as Mirbeau and Geffroy, Monet constructed a myth for himself as a heroic, self-created artist whose work evolved through a dynamic, self-directed process (Spate 1992: 10). Like other artists of his day, Monet also was interested in and owned Japanese prints, which had become popular commodities in France. The painting *Cap Martin, near Menton*, which opened this chapter, was influenced by stylistic clichés from Japanese prints, such as an oblique viewpoint and geometrically defined areas of bright colour (Spate 1992: 166). Such dialogues show that the self is never autonomous, but always exists in a nexus of formative interdependent relationships.

Dialogue as I described here, as utterances that are always directed to someone in a unique situation, can be monologic,

dialogic or polyphonic, and this is the second sense in which Bakhtin used the term. To be truly dialogic and polyphonic, verbal communication and social interaction must be characterised by differing points of view. Even though this use of the word 'polyphonic' refers to spoken and textual dialogue, might we read Monet's brushstrokes as polyphonous? I would suggest that the unique visual contest of colour or directionality of marking in an artwork does express a dialogic and polyphonic sensibility. Colours meet and interact. Complex lines together define three-dimensional form. Analogously, there is an implicit dialogue in any artist's serial procedure, in which a similar scene is painted under differing conditions, or the same form is sculpted numerous times. Monet's later series of *Haystacks* from 1890 and of *Rouen Cathedral* from 1892–93 were the result of his experiments on the Mediterranean.

Polyphony is related to the third sense of dialogue. For Bakhtin, life itself is a dialogue since simply being alive means participating in a network of conversations. We know ourselves, others and the world through dialogue, which is therefore epistemological. Monet's dialogue at this level has indeed left us a considerable legacy of perception and knowledge about the world. Where dialogue describes the process and practice of communication and relationship among selves, the concept of the chronotope describes the time/space nexus in which life exists and creativity is possible.

Time, outsideness and the chronotope

Monet's work not only expressed a profoundly answerable and dialogic relationship with persons and with his environments, but it can also be seen as an extended meditation on time, duration and change. There were several different dimensions to his experience of time during the Mediterranean journeys that often conflicted with one another and are difficult to reconcile (Pissarro 1997: 32).

First, there was the emotional and psychological time related to his separation from Alice, as well as the anxiety created by his need for time to work and his worries about their future. He also experienced the flow of natural time, time made visible in the phenomena he studied such as the changes in light, weather or tides. As his letters indicate, he was frequently frustrated because the very ephemerality of these phenomena made representing them difficult. In terms of depicting light, Monet experimented with three pictorial devices that had been used by others. Like Rembrandt, he tried to capture shadows and tonal values. Establishing relationships of sonorous and rich colours, Monet magnified the role of colour as Delacroix had done. Monet's use of white and the luminosity of his colour were similar to Gerome's painting in the Sahara Desert (House 1986: 110–33).

Furthermore, Monet's pictorial time, the actual time it took him to work out a series or to complete a study or painting, is evident in his many paintings of the Ducal Palace and the Grand Canal in Venice. Differences in the same scene, painted at the same time on subsequent days, demonstrate his focus on light, colour and atmosphere. In addition, part of the time frame of Monet's work can be called mechanical or industrial time, which he, for the most part, avoided representing (Spate 1992: 10). His painting practice may, in fact, be seen as a form of resistance to the forces of industrialism, which may also account for its ongoing popular appeal into the twenty-first century.

Bakhtin would have called all of these types of time 'small time' – the present, recent past and foreseeable future. He posited 'great time' as a category for understanding cultures and cultural artifacts, where the dialogue with a work of art cannot be finalised. For many, Monet's paintings have already entered great time, simply because of their immense success as commodities and ongoing popularity. But, as Bakhtin suggests, the ability to perceive this great time is based not on a grand historical metanarrative, but on a nuanced appreciation of outsideness and the chronotope.

With the concept of outsideness, Bakhtin wanted to show that self and other are only knowable because of boundaries that frame and define the self in relation to others and the world. I see this quality of outsideness articulated in Monet's work in a particular way. For example, cities and urban life in general need an other, an outside that functions to demonstrate what cities do and do not offer, to function as both a foil and frame (Clark 1984: 198). The country and nature itself provided that outside standpoint for Monet. By the time of his first Mediterranean sojourn, Monet had clearly turned away from the untidiness of urban change, preferring to explore what each new environment offered in terms of other pleasures. Perhaps, as T.J. Clark has observed, nature possessed a consistency that nothing else did (1984: 180, 184). How curious it is, however, that what Monet chose to capture was change itself. Many nineteenth-century landscapes (John Constable's paintings, for example) were celebrated for their orderliness and domesticity. But Monet represented elements that could never be domesticated, and that, of course, was his challenge in the Mediterranean environments.

Bakhtin's concept of the chronotope gives us a language for further specifying the nature of Monet's relation with particular times and unique places. According to Bakhtin, there is no experience outside of time (*chronos*) and space (*topos*), both of which always change: 'Time…thickens, takes on flesh, becomes artistically visible; likewise, space becomes charged and responsive to the movements of time, plot and history' (Bakhtin 1981a: 84). In fact, change is essential. Therefore subjectivity and created objects are always constituted differently, something we clearly know in Monet's painting.

I believe we can incorporate some of Bakhtin's literary insights in analysing paintings, but we must describe the chronotope somewhat differently. Certainly we could talk about the chronotopes of various genres of painting using examples primarily from Monet's century: in history painting, or in the

neoclassical and romantic spins on history painting; in religious or mythological subjects; in portraiture; or in landscape in general. Each of these genres can be examined in terms of the distinct ways in which time and space are represented. It is obvious, for instance, that history painting expresses a different self-consciousness about historical events than does landscape painting or portraiture, even when a particular moment is evoked through a place or person.

Consider, for instance, Monet's representation of trees in landscapes painted during the three Mediterranean journeys. Monet reputedly kept one of his 1884 paintings of palm trees for most of his life, even though he complained in a letter to Alice that 'these damn palm trees are driving me crazy' (Pissarro 1997: 33). Several paintings from 1888 of trees by the seashore in Antibes carry enormous eloquence. They are gestural, living in community or alone by the water, and they seem to express emotion and interconnection, even generosity, as they lean into one another. Perhaps the trees are surrogates for people or for the human body. They can certainly be read as emotional signifiers,[3] but they exist in particular moments and unique spaces. Later, in the early 1890s, Monet struggled with painting a 15-part series of poplars. From 1918 to 1919 he painted the series of ten weeping willows mentioned earlier.

The entirety of Monet's painting, including all of these series of trees, may be interpreted as his attempt to visualise successive chronotopes, unique moments in time and space. Similarly, when the artist painted Venice's Grand Canal (Figure 8), the Ducal Palace, and San Giorgio Maggiore over and over again in 1908, he was seeking to capture the fugitive changes that define particular moments. Monet's six paintings of the Grand Canal are almost exactly the same size, and they are considered one of his most systematic series. He represents the sea and scene in almost identical compositions at the same time of day. Still, there are compositional differences, such as the changing water

level that reveals palace steps in three of the six paintings. The atmospheric qualities of Monet's painting also vary, from hazy conditions in the city where the colours are monochromatic, to brighter conditions where he used strong red, green and blue tones.

But there is another relevant sense of the chronotope, which concerns chronotopic motifs that function as a kind of condensed reminder of a particular kind of time and space (Morson and Emerson 1990: 374–75). For instance, the villas depicted in Bordighera are not just any kind of building; they are saturated with a specific sense of time and history. The image of the palace has its own metaphoric resonances, as does the road that I

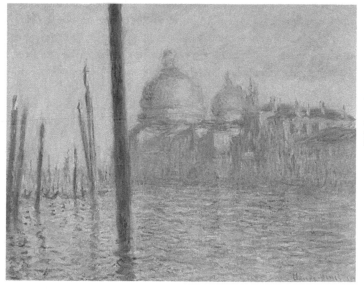

8. Claude Monet, *The Grand Canal* (1908), Photograph © 2012 Museum of Fine Arts, Boston.

described at the outset of this chapter. Such images not only carry all of the specificity associated with particular sites or particular journeys, but they function to evoke other resonances as well: power, privilege, the sense of life itself as a path or journey and so on. To speak of chronotopic motifs thus offers another way of articulating how images carry symbolic temporal and spatially defined meanings.

In the end, the chronotope helps to explain the fact that everything happens not only within a nexus of answerable dialogues, but also that no artifact of culture ever exists outside of particular moments in historical time and space. Monet was indeed compelled by the particular moment, but the chronotope in his painting was unlike either Homer's epics or Dostoevsky's novel, which Bakhtin discussed. Unlike the epic most of Monet's paintings seem to have no historical past, and unlike the novel they also seem to have no future. His images exist in the timeless present; even Venice is represented ahistorically. We see in the artist's work a succession of brief chronotopes, unrepeatable moments in time and space. Much of his expressed frustration regarding the finish and completion of his paintings was a function of this fundamental characteristic of his process.

Unfinalisability and 'finish'

The reasons for Monet's frustration can be described succinctly using Bakhtin's concept of unfinalisability, which articulates a multilayered set of values about creativity, innovation and the new, freedom and potentiality (Morson and Emerson 1990: 36–37). Bakhtin believed that nothing conclusive has yet taken place in the world. He saw the world as open and free, where everything always remains in the future (1984a: 166). Clearly the concept of unfinalisability does not help us to specify further differences in the levels of completeness in Monet's painting or between the incomplete étude and the fully realised tableau, but I think it does offer a more inclusive concept for thinking about Monet's larger

agenda. When is a work finished? Can it ever be truly finished? When is a critical perspective or audience reception complete? Monet preferred to call his paintings 'completed' rather than finished. In 1893 he wrote, 'Anyone who says he has finished a canvas is terribly arrogant' (House 1986: 157). Such language suggests that he intuitively understood this insight.

As I noted earlier, the creative process is unfinalisable except insofar as an artist says, somewhat arbitrarily, 'This work is complete, at least for now'. Monet's use of serial painting processes, including the ways he began to change his process, emphasised the uniqueness of each moment and each painting in terms of subject matter and time, aspects such as time of day, weather, wind, light, season, colour of the sea, tidal level and other perceivable details. His decision to stop could never be final and conclusive, and this was something he wrestled with throughout the later decades of his life. The fact that Monet's paintings continue to generate scholarly and public interest also verifies the central insight of Bakhtin's concept.

Working in the open air on the Italian and French Rivieras, in Antibes or in Venice, Monet was seldom able to bring his paintings to a suitable state of completion. He would later prepare them for sale in the studio. Whether retouching paintings in order to define and further develop contrasts or in order to harmonise the colours and textures, Monet claimed that he was always doing 'what I think best in order to express what I experience in front of nature…to fix my sensations' (House 1986: 182). Precisely because it is always open to change and transformation, artistic work can be a model for change in the larger world outside of the studio. Indeed, unfinalisability gives us a way to speak about the problems of representing our impermanent world through the lens of our diverse, individual, evolving subjectivities. The fact that Monet's life work seems to be, at least from one standpoint, about representing that open-ended flux is certainly another part of its enduring legacy.

In concluding this case study of Monet's work, I offer one last observation about the worlds that Monet and Bakhtin inhabited. Each man expressed in his art (if not always in life) a profound optimism, a benign view of the world and a thorough lack of gloom, even under conditions of economic or political adversity. Monet's letters may express his discontent and fears regarding whether his paintings were adequate for the tasks he undertook. With few exceptions, his works from the 1880s represent neither the pervasive industrial changes of the period – the chimneys and smokestacks, the factories and stultifying labour the population was forced to engage in – nor later do they directly represent the devastating Great War. Bakhtin, of course, lived in exile through the worst parts of Stalinist repression, forced to work in relative obscurity as a bookkeeper and teacher, while some of his closest intellectual colleagues were murdered or sent to die in the gulags of the Russian Far East. His writing did not overtly reflect this context of suffering and repression. In our world, which is characterised by even more pervasive suffering and degradation of the environment, their optimism is refreshing.

I began this chapter by invoking Émile Zola's appreciation of Édouard Manet's art as an expression of genuine beauty. Roger Marx noted the same about Monet's painting in 1909: 'He causes us to know and to love beauty everywhere' (in Stuckey 1985: 268). Whether it be the long northern winter or the blistering southern summer, republican democracy or totalitarian regimes, we need visions of the beauty of the world, reminders that all of life must remain open to dialogue, change and transformation.

Chapter 6

Context, reception and audience

Artist Joseph Beuys (1921–86) defined social sculpture as an interdisciplinary and participatory process in which everyone is an artist. Instead of viewing the aesthetic as a narrow realm where particular media or particular individuals are valorised, he wanted to connect the aesthetic to the ethical, though this is my language, not his. The term 'social sculpture' was multivalent for Beuys and remains so in contemporary usage. As Joan Rothfuss, curator of an exhibition of Beuys's work, commented:

> It might broadly be defined as a conscious act of shaping, of bringing some aspect of the environment… from a chaotic state into a state of form, or structure. Social sculpture should be accomplished cooperatively, creatively, and across disciplines… All around us the fundamentals of life are crying out to be shaped, or created.[1]

Had he been familiar with Beuys, Bakhtin would have understood these values.

Beuys's description of social sculpture aptly represents the ongoing work of artist and writer Margot Lovejoy.[2] A distinguished historian of new media, Lovejoy's installation and web works have been exhibited internationally, and she has lectured widely on technology and art. As a pioneer in the digital arts, Lovejoy published one of the earliest surveys of this art, just a few years after the Internet became viable as a site for artists' work. A

second edition of the book *Digital Currents* was published in 2004. She has also developed a number of interactive websites. *Parthenia* (1995) was her first web project, which grew out of a museum exhibition dedicated to victims of domestic violence. The still-active website contains narratives and images about individual experiences, and invites online visitors to leave their stories. *Salvage* (1998) explores how one recovers from trauma and is based on Adrienne Rich's 1973 poem 'Diving into the Wreck'. *Storm from Paradise* (1999) was a collaborative video installation developed with Miles Dudgeon. It raises questions about the political, social and scientific choices that have guided transitions from the nineteenth to twenty-first centuries. As with her earlier work, this piece also deals with memory and healing.

Lovejoy's *Turns* project (Figure 9) is a social sculpture in Beuys's sense. An interactive website initiated in 2001–2, it invites online viewers to share turning-point stories in their

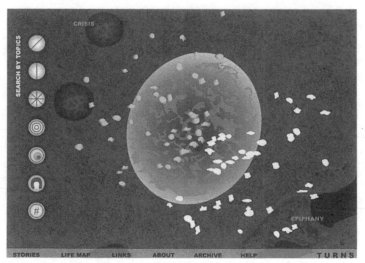

9. Margot Lovejoy, *Turns* (2001–2).

lives. It is about community building insofar as it is focuses on the collection and sharing of a decision from an individual's life history that effectively *turned* that person's life direction. Perhaps this transformation might have been an insight that arose out of an extreme crisis; perhaps it involved the sudden perception of the essential meaning of personal events. By sharing experiences - telling stories and posting images – on Lovejoy's visually engaging website, participants are enabled to explore their narrative in relation to others' stories through lenses such as gender and ethnicity, different circumstances, and times in one's life. *Turns* was selected for the 2002 Whitney Biennial and has been widely exhibited in Europe and Asia. In its latest online iteration, viewers are also invited to submit 'lifemaps', visual images that describe how they have come to terms with the events of their lives.

In referencing a number of artists, including Lovejoy, this chapter has three main goals. First, I outline details of Bakhtin's historical context, including political, social and aesthetic developments that helped shape his life and thought. However, Bakhtin did not write specifically about these topics. Second, I briefly describe the reception of his work, both before and since his death. Third, the contemporary context in the first decades of the twenty-first century is enormously complex and dynamic. In particular, multicultural and cross-cultural influences in our era of globalisation affect all aspects of the arts, from production to consumption in a global marketplace. In this context the artist must ask: For whom do I make art? Where does my art belong? How is it possible to communicate most effectively with my chosen audience? In this section of the chapter I discuss possibilities for 'ethical aesthetics'. The art of Margot Lovejoy, Mark Amerika and Bjørn Melhus provides a glimpse into the ever-evolving domain of digital arts where the aesthetic and ethical are inextricably linked.

Bakhtin's historical context

Bakhtin was remarkably silent about the years following the Revolution of November 1917, which marked the reorganisation of the Soviet government. Civil war raged between mid-1918 and March 1920, and was not completely over until 1922. During this period the Russian Communists successfully eliminated internal opponents and extended the country's boundaries.[3] Other conflicts were simultaneously underway and, along with severe droughts and famine during 1920–22, the number of people who died reached 20 million. The only indication of Bakhtin's personal situation during this time comes from a letter he and his wife wrote to Matvei Kagan in which they alluded to his having been sick for more than a month (1981b: 262–63).

Begun in spring 1921, Lenin's New Economic Policy led to a revival of the economy, which meant the end of grain confiscations and the restoration of a limited free market economy. Although heavy industry and finance remained under governmental control, handicraft and cottage industries were revived. Increasing expenditures were made for social services, progressive schools were opened and private publishing houses operated. With the consolidation of the Union of Soviet Socialist Republics under a new constitution in early 1924, a period of economic recovery from revolution and war combined with greater political stability within the international community. Yet it was also a time of contingency on many fronts.

Russian philosophers such as Nicholas Berdiaev and Vladimir Solovyov identified three attitudes that dominated the first quarter of the twentieth century: Prometheanism, sensualism and apocalypticism (Billington 1966: 475–519), each of which can be located in Bakhtin's writings of the early 1920s. Prometheanism refers to the Greek god Prometheus, who created humans and was later chained to a mountain by Zeus because he gave us fire and the arts. In this context it means the belief that human beings, when aware of their creative powers, are able to transform the

world. It is just this Promethean power that Bakhtin identified as the special province of the artist. By giving birth to new ways of thinking, Bakhtin asserted that 'the artist and art as a whole create a completely new vision of the world' (1990: 191).

Sensualism not only referred to the preoccupation with sex that is exemplified in Solovyov's *The Meaning of Love* and Alexandra Collontai's writings on free love between 1919 and 1925, but may also be seen in what art historians call 'neoprimitivism' in painting, with its explicit inspiration from old Russian folk culture. In Bakhtin's early texts this sensualism is apparent in his emphasis on the body in time and space, and on the importance of embodiment as a literal necessity for a deed to be accomplished.

An apocalyptic attitude was more dominant in Russia during this period than elsewhere in Europe, and seems to have had political, social and religious roots. Vladimir Solovyov was explicit about the sense of apocalyptic expectation: 'The approaching end of the world is wafted to me as a kind of clear, though elusive breath – just as a wayfarer feels the sea air before the sea itself comes into sight' (1974: 27). In this apocalyptic mood, artists were identified as having a special function. Exemplifying this vividly, the Russian artist Mikhail Matyushin wrote: 'Artists have always been knights, poets, and prophets of space in all eras. Sacrificing to everyone, perishing, they opened eyes and taught the crowd to see the great beauty of the world which was hidden from it' (Henderson 1983: 368). Many examples of apocalypticism in the arts can be identified: Wassily Kandinsky's repeated use of themes of the Deluge and Last Judgement in his paintings, Zamyatin's novel *We*, and the mystery plays of Scriabin and Mayakovsky. Even Bakhtin's interpretation of the philosophical crises of his time can be understood in these apocalyptic terms. Radical new thinking was called for, and Bakhtin attempted to provide it.

But the Prometheanism, sensualism and apocalypticism that dominated the first decades of the twentieth century in Russia,

and the series of artistic styles that expressed these attitudes, were short-lived. Such attitudes and styles varied in their emphasis on the spiritual, philosophical and formal aspects of art and the artist's role in the culture. As I discussed in Chapter 1, artists initially revised the nineteenth-century aesthetic theory of art for art's sake, seeking, as Bakhtin might have put it, an art that is answerable to life, an art for life's sake.

Artistically, the early years of the twentieth century were dynamic, as many new styles and movements developed. But by late 1921 some artists and writers had begun to leave the country because of widespread difficulties. Anton Pevsner went to France, while his brother Naum Gabo went to England and then the United States. Kandinsky moved to the Bauhaus in Germany. El Lissitzky also left Russia. Gorky moved first to Germany, then to Italy. Mikhail Bulgakov left Moscow for the Caucasus. Among writers and artists who remained in Russia, numerous publications appeared and exhibitions occurred during the following years. A number of international exhibitions introduced new audiences to artists of the Russian avant-garde.

In politics the period following Lenin's death in early 1924 involved intense struggles for power between different factions of the Soviet government. By 1928 Stalin had consolidated his dictatorship, which lasted until 1953. The purges of the 1930s were especially sweeping; Bakhtin had already been exiled during the 1928–30 persecution of intellectuals. Churches and monasteries were closed during these years and unofficial religious organisations banned, including the Brotherhood of Saint Seraphim, of which Bakhtin was a member (Clark and Holquist 1984: 140). Among artists who stayed in Russia past the late 1920s, the artistic experimentation of the early twentieth century was replaced by conservative mandatory practices that matched Stalinist ideologies in the 1930s and 1940s.

Such political and cultural events aside, Bakhtin's writing may also be seen in relation to the larger discussions and

debates about the relationship of form and content that characterised Russian Symbolism, Futurism and Formalism. For the earlier positivists, against whom the Symbolists revolted, form was simply the outer expression of content, a 'purely external embellishment with which one could dispense without any appreciable damage to communication' (Erlich 1981: 35). The Symbolists wanted to eliminate this kind of mechanistic dichotomy. For Russian Symbolists in particular, art became a form of higher knowledge, capable of revealing ultimate truth and the unknown. These writers and artists believed that metaphors were extremely important vehicles for revealing truth. Further, far from being an external embellishment of content, form was seen as integral. In fact, as one Symbolist, Vyacheslav Ivanov, put it, 'form becomes content, content becomes form' (Erlich 1981: 35). These values led early Symbolists to focus on the problems of poetic language and form. But by 1917 most writers and artists recognised that Symbolism would never regain the earlier stature it had attained during the first decade of the twentieth century.

Although the relationship of Symbolists to Futurists and later Formalists is complex, one can simply say that these latter two groups took a radically different view of form and content. Disdaining the Symbolist exaltation of symbol and content, artists and writers such as Olga Rozanova and Alexander Kruchenykh believed that form *determines* content. In her vivid essay of 1913 'The Bases of the New Creation and the Reasons Why It Is Misunderstood', Rozanova declared that modern art no longer needs to copy objects or nature. She urged instead 'the full and serious importance of such principles as pictorial dynamism, volume and equilibrium, weight and weightlessness, linear and plane displacement, rhythm as a legitimate division of space, design, planar and surface dimension, texture, colour correlation, and others' (1988: 108). All of these are formal aspects of art; Rozanova's abstract collages and drawings for Kruchenykh's poetry would later illustrate such concerns.

Russian Formalism originated with the formation of the Moscow Linguistic Circle in 1915 and the Society for the Study of Poetic Language in 1916 in St Petersburg. If, as suggested earlier, the Symbolists had helped to create an interest in poetics linked to philosophical and metaphysical thought, then the Formalists followed the Futurists in subjugating content to form. Victor Shklovsky, a leading Formalist, stated this idea plainly in 1923. The Formalist method, Shklovsky claimed, 'does not negate the ideological content of art, but considers the so-called content as one of the aspects of form' (Erlich 1981: 187). Because of the inherent difficulties of the form/content dichotomy, not the least of which was the problem of defining form clearly, many Formalists later dropped the category of content in favour of 'material', the materials or devices used in visual art and writing.

I developed Bakhtin's aesthetic philosophy at some length in Chapter 1, but here I would add a few words about why he criticised Formalist and materialist perspectives. This will serve to highlight Bakhtin's disagreement with his contemporaries. He understood that by aligning themselves with linguistics, Formalists were trying to find ways of accounting for general aesthetic principles as well as the nature and material of artistic creation. Bakhtin thought this perspective problematic. On the surface, the Formalist focus on material creates a kinship with empirical science, thus rendering the conclusions of such scholarship objectively scientific. This seeming advantage was actually an illusion. Bakhtin, too, wanted to understand the linguistic qualities of the word, especially in poetry, but he would then examine its significance in relation to art, science, religion and philosophy. In keeping with its goals, Formalist linguistics would stop at the first task. For Bakhtin an utterance only comes alive and acquires meaning in cultural and personal contexts, while linguistics sees an utterance only as a phenomenon of language that 'masters' its object while being indifferent to extralinguistic values of language (1990: 292–93). In Bakhtin's

view, this partial and therefore flawed way of understanding the complex interrelationships of content, form *and* material was the result of Formalist ideas.

Bakhtin was certainly not alone in such criticisms of the materialist aesthetics of the Formalists. In three essays written between 1910 and 1913, artist Wassily Kandinsky developed an analogous point of view. In 'Content and Form' the artist stated that 'only that form is correct which expresses, materialises its corresponding content' (1982: 87). Later, in 'On the Question of Form' (1911–12) and 'Painting as Pure Art' (1912–13), he continued this meditation on the relationship of content and form by insisting again that 'form is the external expression of inner content' (Kandinsky 1982: 237). Kandinsky, whose views were similar to Bakhtin's, claimed that a work of art must express the inevitable and inseparable joining of content, the inner element, with form and material, the outer elements.

These events up to the 1920s, both political and artistic, indelibly shaped Bakhtin's life and were foundational for everything that followed. Two further events in his personal life during this early period were also formative. First, in 1921 he married Elena Aleksandrovna Okolovic, who remained his companion until she died in 1971. She effectively took care of him after bone disease resulted in a leg amputation in 1938. Second, the couple moved back to Leningrad in 1924 so that Bakhtin could work at the Historical Institute. His consulting at the State Publishing House during this period was essential to the publication of his 1929 *Problems of Dostoevsky's Art*, which was finally translated into English in 1981.

As mentioned earlier, Bakhtin was exiled to Kazakhstan in 1929, where he spent six years in Kustanai (now Kostanay). Then, in 1936, he moved to Saransk in order to teach at the Mordovian Pedagogical Institute. In 1937 he and Elena moved to Kimry, much closer to Moscow. From 1940 until the end of World War II Bakhtin therefore lived near enough to Moscow to engage with

the educational and publishing communities there. Nevertheless, his working relationships in Saransk continued. He became the chair of the General Literature Department, and later the head of the Department of Russian and World Literature. Due to ill health, he retired in 1961 and moved back to Moscow in 1969, where he remained until his death in 1975.

Reception of Bakhtin's ideas

No simple narrative can be told about the reception of Bakhtin's ideas and the dissemination of his books and essays, both before and since his death. In beginning to address this issue, I experience a deep conundrum: how much should I describe the reception of his ideas here? On the one hand, this book may be the reader's first encounter with Bakhtin. I therefore think that it should be like the proverbial finger pointing at the moon in Buddhist iconography, simply indicating the directions that Bakhtin's reception has taken. On the other, I feel a responsibility to acknowledge initial differences in reception between the early Bakhtinians and European and North American interpreters. This Russia/West divide characterised Bakhtin studies until the mid-1980s to early 1990s. Other significant differences in the interpretation and reception of his work are based especially on generations of scholars and the disciplines in which they work. Here I choose a middle path between these options. The reception of Bakhtin's writing is a massive topic and could well be the subject of a large volume of its own.[4]

While differences in reception between Russian and English-speaking interpreters of Bakhtin's work in the twentieth century are of historical interest, two more important ongoing distinctions may be made. First, the reception and interpretation of Bakhtin's work differs greatly among his contemporaries and immediate students – scholars such as Sergei Bocharov, Georgii Gachev, Vadim Kozhinov and Leontina Melikhova – and the younger generation of scholars in Russia and abroad – individuals such as

Vitaly Makhlin, Caryl Emerson and Brian Poole. Turf wars continue to be played out among scholars of different generations in Russia and elsewhere, with conflicting stories and interpretations that have led to divisions, and even personal hatred, in the worldwide Bakhtin community (Emerson 1997: 59).

The second crucial divide in the interpretation and reception of Bakhtin's work concerns differences between literary scholars and those more inclined toward philosophy. Those who are most interested in literature and language usually begin and end with the text – Dostoevsky, Tolstoy or Emily Dickinson, for example – where the focus is on using Bakhtin's ideas to explicate the creative work of particular poets, writers and artists. Taken into other disciplines such as film studies or art history, interpreters use particular concepts to illuminate the work of film theorists and filmmakers from Christian Metz to David Mamet. The previous chapter of *Bakhtin Reframed* on Claude Monet may be considered an example of this approach within art history.

Notwithstanding my own engagement with Bakhtin's ideas as useful interpretive tools – for instance, in relation to Monet's Mediterranean paintings or painter Kazimir Malevich's early abstract work – I locate myself in the camp of those most absorbed by the philosophical ramifications of Bakhtin's life and work. Such scholars might focus on specific philosophical or religious topics: Bakhtin's relationship to Kant, Hegel or Marx; how his work foreshadows certain strands of postmodernism; or the incorporation of Russian Orthodox beliefs into his theories. More generally, and consistent with the fact that Bakhtin was not a 'conventionally "academic" literary scholar' (Emerson 1997: 207), a philosophical approach to Bakhtin's oeuvre helps us with the vexing questions of how to think, articulate our core values, live and act in the world. To engage his work in this way is not easy since it means slowing down, approaching Bakhtin's ideas with a curiosity more akin to his own style of roundabout musing and humility.

At the 1995 Bakhtin Centennial Conference in Moscow, Russia, I had the good fortune to be part of a large audience that heard, for the first time, the recording of an interview made by Victor Duvakin in early 1973, when the ailing Bakhtin was 78 years old. Overall, Duvakin's interviews totalled 18 hours. Sitting in a large auditorium at Moscow State Pedagogical University, we were privileged to hear the final minutes of the final session of Duvakin's recordings, during which Bakhtin recited verses from Goethe, Rilke, Pushkin and Baudelaire. His last words bespeak the humility that characterised Bakhtin's presence and personal style: 'Excuse me for having been so incoherent all this time' (Emerson 1997: 33).

There are indeed many 'Bakhtins' in scholarly worlds ranging from Moscow to London, Austin to Singapore. As Morson and Emerson noted in their introduction to *Rethinking Bakhtin*, 'Any thinker with original and challenging views is subject to degrees of misunderstanding, superficial readings, and careless appropriations of terminology' (1989: 46). In Bakhtin's case these challenges have been amplified by inconsistent or long-delayed translations, by the lack of familiarity with Russian thought more generally, and by the fact that Russian is not a well-known language in most of the world.

Finally, I would point the novice reader to a major resource about Bakhtin that indicates the wider reception and interpretation of his work. Founded in 1994, the University of Sheffield Bakhtin Centre maintains the largest searchable database of publications on Bakhtin and the Bakhtin Circle, as well as on related theoretical topics regarding culture, linguistics and literature. Since the year 2000 in the English-speaking world alone, many books and articles have appeared that reflect the adaptation of Bakhtin's work by scholars in a wide range of academic disciplines. All these are accessible via the Bakhtin Centre website.[5]

The contemporary context

In reflecting on the context of contemporary life, I turn not to specific political, social, economic, or environmental events and processes, but to a meditation on what I have come to call 'ethical aesthetics'. The German philosopher Arthur Schopenhauer (1788–1860) once wrote that thinking for oneself does not mean thinking in isolation (1851). This statement contains an insight especially applicable to our context. We are surrounded by dangers ranging from ecological catastrophe and global climate change to extreme violence in communities all over the world. The arts seem to be undergoing a process of rapid dematerialisation and (d)evolution, where strategies of appropriation, pastiche and remix dominate. Even if the arts remain a narrow zone of creative activity within our bureaucratised and technologised cultures, I believe that we need visual art that is based on ethical aesthetics and informed by an apocalyptic sensibility.

This statement directly reflects what I have learned through sustained study of Mikhail Bakhtin's moral philosophy. He taught me to think about the necessary interconnections of ethics and aesthetics, as I outlined in Chapter 1. To review his perspective: Bakhtin was thoroughly familiar with the Kantian framework, which separates science, ethics and aesthetics into three autonomous spheres. He considered this separation a wrong move with, as I believe, disastrous consequences. In a world of totally rationalised science and technology, ethics limited to narrow definitions of 'family values' and the like, and aestheticised arts unconnected to life, it is no wonder we are in the midst of quarrelsome debates about nuclear energy, weapons and waste, about genetic engineering, and about censorship and freedom of speech. Ethical aesthetics does not hesitate to engage questions about technology; indeed, it seeks to reconnect the aesthetic to the scientific and ethical domains of culture.

Hegel first articulated the idea of the end of art in 1827. Since then, whenever new conditions and new technologies have

challenged the old, some philosophers, theorists, historians and artists have responded with predictions of the death of art, the death of painting or the end of museums. Now the nature of art itself is changing dramatically, with the accessibility and ubiquity of digital media and the evolution of new genres such as installation and performance, land art and hybrid forms of digital art. The dematerialisation of the art object, begun with twentieth-century conceptual art, continues in new guises. We live in what Barbara Stafford so vividly described more than 20 years ago as an 'image world', where the technical means of the media – television, film, photography, computers, billboards and the like – intersect the world of art (1991: 471). These worlds require informed and trained designers, artists and architects, each of whom brings a unique perspective to the tasks of interpreting and reshaping the present and future. Beyond this, the horizon before us contains the distinct possibility of annihilation. I do not mean to be melodramatic, but the conditions of contemporary life elicit this apocalyptic sensibility. Ever more resistant viruses, increasing extinctions of species, ongoing degradation of the water and air, skyrocketing world populations: most of us know the litany all too well.

Here, nearing the end of *Bakhtin Reframed*, I want to expand on what ethical aesthetics might actually look like for the artist and historian by using three models of cultural criticism to describe three types of artists. Analysing the utopian, utilitarian and apocalyptic aspirations of new media art not only provides a lens for interpreting them, but these categories are also useful for thinking about how the artist functions within contemporary cultures as radical humanist, radical technologist or radical ecologist.[6] I think of these categories as a matrix, with intersections and crossovers among them.

An artist driven by utopian aspirations might articulate a general optimism about technology's role in our lives: the idea that we can solve our problems by increasing our engagement.

From this point of view, the Internet and cloud technologies are presently *the* place for the expansion of participatory democracy and community. They will transform education and work opportunities for all of us, especially as issues of access are worked out. Artists working in this mode might be considered radical humanists, advocating the employment of evolving technologies to build new communities, and extending the range of human perception and performance.

Margot Lovejoy's online projects exemplify this approach. I have already described how her work on interactive websites is intended to create online communities that did not previously exist. Beyond this, Lovejoy has been articulate about some of the challenges of working within the contemporary art world. When I interviewed her, she was blunt about what it means to work as a woman artist. As women artists get older, Lovejoy said, it is hard for their work to be shown if they have not been 'anointed'. This is especially true today. Under the forces of globalisation, many artists from diverse cultures are joining the art world fray, which creates tough competition for exhibitions and critical reviews. When work is not saleable, such as Lovejoy's, the artist must depend on websites, artists' books and digital photographs. The questions of who one's audience is and how to reach that audience are huge. But the biggest question and biggest challenge, Lovejoy emphasised, is how to stay true to one's own artistic vision. We should heed her wise words.

An artist driven by a utilitarian perspective emphasises the practical side of contemporary life. Artists working in this mode might be thought of as radical technologists. As an ethical philosophy, utilitarianism is based on the premise that the rightness or wrongness of an action or idea is determined by its usefulness in promoting the most happiness and pleasure for those involved. From this perspective, our world – characterised by engagement with highly entertaining and seductive technologies such as television, the computer and ever-smaller hand-held

mobile devices – is a utilitarian paradise. So much information is available to us so much more easily than it used to be. We engage in research from our homes, artists create their own online communities and curators create their own ideal museums.

The author and artist Mark Amerika and his collaborators have been proactive in imagining and creating new types of Net art, the most recent being the 'Glitch Museum', which went live during the London 2012 Olympics as part of an arts 'olympiad'.[7] Amerika is the author of many books, two of which address theories of new media and emerging forms of remix writing and art (2007 and 2011). He describes his writing, which cannot be separated from his visual art, as 'improvisational, nomadic, surfing on the elliptical edge of its own possibility' (2007: xvi). An artist who performs internationally, Amerika also recognises the problem that Lovejoy describes: how to survive in a global art world. As an active cultural publisher of the Alt-X Online Network, he has been able to support hundreds of scholars and artists in further developing their audiences. He believes in and chooses to work within the 'gift economy', a term that was well defined by Lewis Hyde (1983). As Amerika wrote: 'This means that I have gone out of my way to give away my work for free over the Net. I also try to invest my valuable time in finding ways to make the best work being developed by my peers freely available over the Net' (2007: 176). This is clearly a utilitarian aspiration in the best sense – an attempt to promote the wellbeing of others.

The artist as radical ecologist may be utopian like the radical humanist, and pragmatic like the radical technologist. But such an artist has a decidedly more apocalyptic vision. To be a radical ecologist means paying attention to how all things and events are connected. It means asking whether it is possible to modify individual and cultural consciousness. It does not mean articulating simply, as performance art pioneer Rachel Rosenthal did in *filename: FUTURFAX*, that 'We are all waiting to die with time on

our hands'. Many contemporary artists work in this arena, but I see an especially powerful example in the work of Bjørn Melhus, a German artist of Norwegian descent.

Melhus premiered his installation *Still Men Out There* in 2003 in Frankfurt. It has subsequently been installed in venues including Istanbul in 2009 and Denver, Colorado, in 2011. Using 18 television monitors, this light and sound installation brings dramatic attention to how cinema conditions our responses to war. Melhus presents the spectacle of war without images, instead using soundtracks from American commercial films such as *Platoon* (directed by Oliver Stone, 1986), the *Thin Red Line* (Terrence Malick, 1998) and *We Were Soldiers* (Randall Wallace, 2002). The soundtracks include speeches and heroic soliloquies, marching troops and gunfire, as well as nostalgic moments of love. The result is a dramatic and potent statement about the consequences of war. In *Still Men Out There*, the aesthetic and ethical come together seamlessly.

Listening in a darkened room at the Denver Art Museum, watching the light change as the screens flashed, I was reminded of Susan Sontag's *Regarding the Pain of Others* (2003). This book, written shortly before Sontag died in 2004, asks the question that Virginia Woolf posed in her 1938 *Three Guineas*: 'How in your opinion are we to prevent war?' Sontag is not sanguine. Analysing the long history of war photography, she notes that such images may give rise to calls for peace, cries for revenge or, sadly, bemused awareness that terrible things happen. In our era of information overload, the photograph may help us to apprehend something or memorise it. But it is not as simple as this, for images of war and human suffering are so ubiquitous and widely disseminated that many of us have lost the ability to feel. Living in the society of the spectacle, Sontag suggests, 'We don't get it. We truly can't imagine what it is like. We can't imagine how dreadful, how terrifying war is – and how normal it becomes' (2003: 125–26). Without images and without creating a

spectacle, Melhus's *Still Men Out There* makes real the dreadful suffering and inhumanity of war. To call this artist a radical ecologist is a way of acknowledging how he uses aesthetic means to create an enormously effective ethical statement.

Just as Bakhtin's work presents his response to the intellectual challenges and physical hardships of his time, twenty-first-century artists, critics, philosophers of art and art historians must respond in their own ways to our contemporary context. Definitions of what constitutes a work of art, along with the nature of audience reception, have changed dramatically in the era of social sculpture, where the digital works of artists Margot Lovejoy, Mark Amerika and Bjørn Melhus are helping to create new communities and new ways of perceiving the world.

I began this chapter with Lovejoy's online projects, highlighting *Turns* from 2001–2. Her latest ongoing project is *Confess* (2008). The site is organised around seven confessional themes with the goal of creating a community of voices unafraid to share their stories. It builds on Christian and psychotherapeutic values in regard to the power of confession. Bakhtin too wrote about confession and what he called 'confessional self-accounting' in his early essays, especially 'Author and Hero' (1990), and later in his book and notes on Dostoevsky (1984a). About Dostoevsky Bakhtin noted, 'He asserts the impossibility of solitude, the illusory nature of solitude. The very being of man...is the *deepest communion. To be* means *to communicate*' (1984a: 287). Confession is a significant aspect of human interaction and communication because it demonstrates the interrelationship of consciousnesses: 'I cannot manage without another, I cannot become myself without another (in mutual reflection and mutual acceptance)' (1984a: 287).

While Bakhtin's language is obviously religious, what interests me here is the way it brings us back to the crucial interaction of ethics and aesthetics – to ethical aesthetics. *Self and other*, *artist and audience*, *artist and world*: each word in these pairs exists

in a thoroughly interdependent relationship with the other. In the twenty-first century we are called to create out of such an awareness and appreciation of our profound interdependence with others. I imagine that Bakhtin, sitting up in bed toward the end of his life, would have been pleased.

Conclusion

I believe that all of us who are traversing the terrain of the arts today should be conversant with the history of philosophy and with contemporary theory. These can provide part of a comprehensive framework for understanding art of various historical eras and diverse cultural settings. By studying and engaging with aesthetics and other theoretical discourses, artists, art historians and theorists, as well as critics of the arts, will be in a much stronger position from which to interpret their, and our, work.

Bakhtin Reframed has presented Mikhail Bakhtin's most general aesthetic theories, as well as detailed analyses of specific concepts in his oeuvre. In writing about Dostoevsky, he described a peculiar quality of consciousness and of language that is especially pertinent here, at the end of the book. 'A loophole,' he wrote, 'is the retention for oneself of the possibility of altering the ultimate, final meaning of one's words' (1984a: 233). I hope that this book joins the ongoing open-ended dialogue about the meaning and value of Bakhtin's life and work.

Notes

Chapter 1

1 I described this experience in detail in Haynes, Deborah J., *Book of This Place: The land, art, and spirituality* (2009), pp. 70–79.

2 For excellent though divergent discussions of this debate, see Egan, Rose Frances (1921) *The Genesis of the Theory of 'Art for Art's Sake' in Germany and England* (Folcroft, PA, 1921), and Singer, Irving, 'The Aesthetics of '"Art for Art's Sake"', *Journal of Aesthetics and Art Criticism* XII (March 1954), pp. 343–59.

3 For more on Bakhtin's criticisms of impressive and expressive aesthetics, see Haynes, Deborah J., *Bakhtin and the Visual Arts* (1995).

4 Michel Foucault and Gilles Deleuze articulate a similar view of theory in 'Intellectuals and Power', in Donald Bouchard (ed), *Language, Counter-memory, Practice: Selected essays and interviews* (1977).

5 Cobb's work can be seen at http://www.amberdawncobb.com.

Chapter 2

1 The best biography of Bakhtin's life remains Clark and Holquist's (1984) *Mikhail Bakhtin*. Most details about his life in this chapter are derived from this account.

2 Here I expand on descriptions in sources written by a number of scholars: Arthur J. Cropley (1999), Howard Gardner (1993 and 2006), Daniel Goleman (2005) and Mihaly Csikszentmihalyi (1996), among others.

3 My summary is indebted to Caryl Emerson's fine description of Bakhtin's creative life at the outset of *The First Hundred Years of Mikhail Bakhtin* (1997).

4 The URL for the Bakhtin Centre website is http://www.sheffield. ac.uk/bakhtin.

Chapter 3

1 From interview posted by Daniela Stigh and Zoë Jackson, http://www. moma.org/explore/inside_out/2010/06/03/marina-Abramovic-the-artist-speaks (accessed 29 January 2012).

2 See especially the writing of Manuel Gasser (1963), Svetlana Alpers (1988), H. Perry Chapman (1990), and exceptional essays by Ernst van de Wetering, Volker Manuth and Marieke de Winkel in White and Buvelot, *Rembrandt by Himself* (1999).

3 Richard B. Woodward, in 'Roles of a Lifetime', http://online.wsj. com/article/SB10001424052970204653604577249771626916422.html, accessed 21 March 2012.

Chapter 4

1 See Fulton's website http://www.hamish-fulton.com.

2 For their summaries of these themes I am indebted to Morson and Emerson's discussion in *Mikhail Bakhtin: Creation of a prosaics* (1990: 366–432).

3 Among the many books and articles about Finlay's and Graves's art, I especially recommend Yves Abrioux's *Ian Hamilton Finlay: A visual primer* (1992), which includes brilliant text by Stephen Bann, and Ray Kass's biography *Morris Graves: Vision of the inner eye* (1983).

Chapter 5

1 There is a vast bibliography on Impressionism in general and on Monet in particular. Among major scholars whose work has influenced my understanding of Monet's art, I would mention Richard R. Brettel, Norma Broude, T.J. Clark, Robert L. Herbert, John House, Steven Z. Levine, Joachim Pissarro, Jane Mayo Roos, Richard Shiff, Virginia Spate and Charles Stuckey.

2 See, for instance, comments about these paintings on the Kimbell Art Museum website, https://www.kimbellart.org/collection-object/weeping-willow (accessed 12 January 2013).

3 I heard Richard R. Brettel analyse Monet's representation of trees along these lines in his lecture 'Dramatis Arbores: Monet's Trees' on 14 June 1997, at the Kimbell Art Museum, Dallas, Texas.

Chapter 6

1 Quoted by curator Joan Rothfuss, Walker Art Center website http://www.walkerart.org/archive/8/9C430DB110DED6686167.htm (accessed 10 April 2012).

2 All of Lovejoy's online projects are accessible at http://www.margotlovejoy.com.

3 For this interpretation of events I consulted *New Cambridge Modern History, Vol XII, The Shifting Balance of World Forces, 1898–1945* (1968), ed. C.L. Mowat, Cambridge: Cambridge University Press.

4 Among books that address these issues, including Bakhtin's engagement with the Bakhtin Circle and the so-called 'disputed texts', see Emerson (1997), Emerson (1999), Brandist (2002) and Brandist, Shepherd and Tihanov (2004).

5 Bakhtin Centre, University of Sheffield, http://www.sheffield.ac.uk/bakhtin.

6 Here I adapt the models of cultural criticism from Sherry Turkle (1995) and the categories of artists from Andrew Ross (1994).

7 See Amerika's diverse writings, Net art and video projects, including links to the new Glitch Museum, at http://www.markamerika.com.

Select bibliography

Abrioux, Yves with Stephen Bann (1992) *Ian Hamilton Finlay: A visual primer*, Cambridge, MA: The MIT Press.

Allison, Philip (1968) *Cross River Monoliths*, Lagos, Nigeria: Department of Antiquities.

Althusser, Louis (1971) *Lenin and Philosophy, and Other Essays*, trans. Ben Brewster, New York: Monthly Review Press.

Ament, Delores Tarzan (2002) *Iridescent Light: The emergence of northwest art*, Seattle, WA: University of Washington Press.

Amerika, Mark (2007) *Meta/data: A digital poetics*, Cambridge, MA and London, England: The MIT Press.

— (2011) *Remixthebook*, Minneapolis, MN: University of Minnesota Press.

Aristotle (1935) *On the Soul*, trans. W.S. Hett, Cambridge, MA: Harvard University Press.

Bakhtin, Mikhail M. (1981a) *The Dialogic Imagination: Four essays by M.M. Bakhtin*, Michael Holquist (ed.), trans. Caryl Emerson and Michael Holquist, Austin, TX: University of Texas Press.

— (1981b) 'M.M. Baxtina M.I. Kaganu' *Pamiat': Istoricheskij sbornik*, vol. 4, Paris: YMCA Press, pp. 249–81.

— (1984a) *Problems of Dostoevsky's Poetics*, ed. and trans. Caryl Emerson, Minneapolis, MN: University of Minnesota Press.

— (1984b) *Rabelais and His World*, trans. Helene Iswolsky, Bloomington, IN: Indiana University Press.

— (1986) *Speech Genres and Other Late Essays*, Caryl Emerson and Michael Holquist (eds), trans. Vern W. McGee, Austin, TX: University of Texas Press.

— (1990) *Art and Answerability: The early essays of M.M. Bakhtin*, trans. Vadim Liapunov and Kenneth Brostrom, Austin, TX: University of Texas Press.

— (1993) *Toward a Philosophy of the Act*, Vadim Liapunov and Michael Holquist (eds), trans. Vadim Liapunov, Austin, TX: University of Texas Press.

Biesenbach, Klaus (2010) *Marina Abramović: The artist is present*, New York: Museum of Modern Art.

Billington, James H. (1966) *The Icon and the Axe: An interpretative history of Russian culture*, New York: Random House.

Boer, Roland (2008) *Bakhtin and Genre Theory in Biblical Studies*, Boston, MA: Leiden.

Braidotti, Rosi (2003) 'Feminist Philosophies', in *A Concise Companion to Feminist Theory*, Mary Eagleton (ed.), London: Blackwell, pp. 195–214.

Brandist, Craig (2002) *The Bakhtin Circle: Philosophy, culture and politics*, London: Pluto Press.

Brandist, Craig, Shepherd, David and Tihanov, Galin (2004) *The Bakhtin Circle in the Master's Absence*, Manchester and New York: Manchester University Press.

Brandist, Craig and Tihanov, Galin (2000) *Materializing Bakhtin: The Bakhtin Circle and social theory*, New York: St. Martin's Press.

Braudel, Fernand (1980) *On History*, trans. Sarah Matthews, Chicago, IL: University of Chicago Press.

Brettel, Richard and Pissarro, Joachim (1992) *The Impressionist in the City: Pissarro's series paintings*, New Haven, CT: Yale University Press.

Brilliant, Richard (1991) *Portraiture*, Cambridge, MA: Harvard University Press.

Broude, Norma (1991) *Impressionism, A Feminist Reading: The gendering of art, science, and nature in the nineteenth century*, New York: Rizzoli.

Budick, Ariella (1997) 'Factory Seconds: Diane Arbus and the imperfections in mass culture', *Art Criticism* 12, pp. 50–70.

Cajkanovic, Veselin (1996) 'Magical Sitting', trans. Marko Zivkovic, *Anthropology of East Europe Review* 14 (Spring), Available from http://condor.depaul.edu/rrotenbe/aeer/aeer14_1/zivkovic.html [1 May 2012].

Casey, Edward (2002) *Representing Place: Landscape painting and maps*, Minneapolis, MN: University of Minnesota Press.

Christian, Barbara (1988) 'The Race for Theory', *Feminist Studies* 14, pp. 67–80.

Clark, Katerina and Holquist, Michael (1984) *Mikhail Bakhtin*, Cambridge, MA: Harvard University Press.

Clark, T.J. (1984) *The Painting of Modern Life: Paris in the art of Manet and his followers*, Princeton, NJ: Princeton University Press.

Coates, Ruth (1998) *Christianity in Bakhtin: God and the exiled author*, Cambridge: Cambridge University Press.

Coleridge, Samuel Taylor (1965) *Biographia Literaria* I, J. Shawcross (ed.), London: Oxford University Press.

Cropley, Arthur J. (1999) 'Definitions of Creativity', in *Encyclopedia of Creativity*, vol. 1, Michael Kelly (ed.) New York: Oxford University Press, pp. 511–24.

Csikszentmihalyi, Mihaly (1996) *Creativity: Flow and the psychology of discovery and invention*, New York: HarperCollins.

Dempsey, Amy (2006) *Destination Art*, Berkeley, CA: University of California Press.

Emerson, Caryl (1997) *The First Hundred Years of Mikhail Bakhtin*, Princeton, NJ: Princeton University Press.

Emerson, Caryl (ed.) (1999) *Critical Essays on Mikhail Bakhtin*, New York: G.K. Hall.

Erlich, Victor (ed.) (1981) *Russian Formalism: History-doctrine*, 3rd ed., New Haven, CT and London: Yale University Press.

Felch, Susan M. and Contino, Paul J. (eds) (2001) *Bakhtin and Religion: A feeling for faith*, Evanston, IL: Northwestern University Press.

Flanagan, Martin (2009) *Bakhtin and the Movies: New ways of understanding Hollywood film*, Basingstoke: Palgrave Macmillan.

Flax, Jane (1989) 'Postmodernism and Gender Relations in Feminist Theory', in Micheline R. Malson et al. (eds), *Feminist Theory in Practice and Process*, Chicago, IL: University of Chicago Press, pp. 51–73.

Foucault, Michel and Deleuze, Gilles (1977) 'Intellectuals and Power', in *Language, Counter-memory, Practice: Selected essays and interviews*, Donald Bouchard (ed.), trans. Donald Bouchard and Sherry Simon, Ithaca, NY: Cornell University Press.

Fulton, Hamish (2008) *Kora*, Oslo: Galleri Riis.

— (2010) *Mountain Time Human Time*, Milano: Edizioni Charta.

Gardner, Howard (1993) *Creating Minds*, New York: Basic Books.

— (2006) *Multiple Intelligences: New horizons*, New York: Basic Books.

Gasser, Manuel (1963) *Self-portraits: From the fifteenth century to the present day*, trans. Angus Malcolm, New York: Appleton-Century.

Ghiselin, Brewster (1952) *The Creative Process*, New York: New American Library.

Goleman, Daniel (2005) *Emotional Intelligence*, New York: Ballantine Books.

Grande, John K. (2004) *Art Nature Dialogues: Interviews with environmental artists*, Albany, NY: State University of New York Press.

Greenberg, Clement (1985) 'Claude Monet: The later Monet', in *Monet: A retrospective*, Charles Stuckey (ed.), New York: Hugh Lauter Lenin, pp. 376–78.

Guyau, Jean-Marie (1947) *The Problems of Contemporary Aesthetics*, Book I, trans. Helen L. Mathews, Los Angeles, CA: De Vorss and Co.

Harding, Sandra (1989) 'The Instability of the Analytical Categories of Feminist Theory', in *Feminist Theory in Practice and Process*, Micheline R. Malson et al. (eds), Chicago, IL: University of Chicago Press, pp. 15–34.

Harris, John (1985) *The Artist and the Country House: A history of country and garden view painting 1540–1870*, New Haven, CT: Yale University Press.

Haynes, Deborah J. (1995) *Bakhtin and the Visual Arts*, New York: Cambridge University Press.

— (1997) *The Vocation of the Artist*, New York: Cambridge University Press.

— (1998) 'Answers First, Questions Later: A Bakhtinian interpretation of Monet's Mediterranean paintings', *Semiotic Inquiry* 18, pp. 217–30.

— (2003) *Art Lessons*, Boulder, CO: Westview Press.

— (2009) *Book of This Place: The land, art, and spirituality*, Eugene, OR: Pickwick.

Henderson, Linda (1983) *The Fourth Dimension and Non-Euclidean Geometry in Modern Art*, Princeton, NJ: Princeton University Press.

Hirschkop, Ken (1999) *Mikhail Bakhtin: An aesthetic for democracy*, Oxford: Oxford University Press.

Hirschkop, Ken and Shepherd, David (eds) (1989) *Bakhtin and Cultural Theory*, Manchester: Manchester University Press.

Hitchcock, Peter (ed.) (1998) *Bakhtin/'Bakhtin': Studies in the archive and beyond*, special issue of *The South Atlantic Quarterly* 97.

Holly, Michael Ann (1984) *Panofsky and the Foundations of Art History*, Ithaca, NY: Cornell University Press.

Holquist, Michael (1990) *Dialogism: Bakhtin and his world*, New York: Routledge.

hooks, bell (1989) *Talking Back: Thinking feminist, thinking black*, Boston, MA: South End Press.

House, John (1986) *Monet: Nature into art*, New Haven, CT: Yale University Press.

Hunt, John Dixon (2004) *The Afterlife of Gardens*, Philadelphia, PA: University of Pennsylvania Press.

Hyde, Lewis (1983) *The Gift: Imagination and the erotic life of property*, New York: Random House.

Irigaray, Luce (1985) *This Sex Which Is Not One*, trans. Catherine Porter, Ithaca, NY: Cornell University Press.

Iverson, Margaret (1993) *Alois Riegl: Art history and theory*, Cambridge, MA and London, England: The MIT Press.

Kandinsky, Wassily (1982) *Kandinsky: Complete writings on art*, vol. 1 (1901–21), Kenneth C. Lindsay and Peter Vergo (eds), Boston, MA: G.K. Hall & Co.

Kane, Richard and Lewis, Melody (2004) Film. *M.C. Richards: The fire within*, Sedgwick, ME: Kane-Lewis Productions.

Kant, Immanuel (1952) *The Critique of Judgment*, trans. J.C. Meredith, Oxford: Clarendon Press.

— (1958) *The Critique of Pure Reason*, trans. Norman Kemp Smith, London: Macmillan.

Kass, Ray (1983) *Morris Graves: Vision of the inner eye*, New York: Braziller.

Kearney, Richard (1988) *The Wake of Imagination: Toward a postmodern culture*, Minneapolis, MN: University of Minnesota Press.

Kemp, Penny and Griffiths, John (1999) *Quaking Houses: Art, science, and community, a collaborative approach to water pollution*, Charlbury: Jon Carpenter.

Kline, Katy and Posner, Helaine (1994) *Leon Golub and Nancy Spero: War and memory*, Cambridge, MA: The MIT List Visual Arts Center.

Krinke, Rebecca (ed.) (2005) *Contemporary Landscapes of Contemplation*, London and New York: Routledge.

Kris, Ernst and Kurz, Otto (1979) *Legend, Myth, and Magic in the Image of the Artist: A historical experiment*, New Haven, CT: Yale University Press.

Levine, Steven Z. (1994) *Monet, Narcissus, and Self-reflection: The modernist myth of the self*, Chicago, IL: University of Chicago Press.

Lewis, Mary Tompkins (ed.) (2007) *Critical Readings in Impressionism and Post-impressionism: An anthology*, Berkeley, CA: University of California Press.

Lindauer, Martin S. (2003) *Aging, Creativity, and Art: A positive perspective on late-life development*, New York: Kluwer Academic/ Plenum Publishers.

Long, Richard and Lelie, Herman (1991) *Richard Long: Walking in circles*, London: The South Bank Centre.

Lorde, Audre (1904) *Sister Outsider: Essays and speeches*, Trumansburg, NY: Crossing Press.

Lovejoy, Margot (2004) *Digital Currents: Art in the electronic age*, New York and London: Routledge.

Medvedev, P.M. (1985) *The Formal Method in Literary Scholarship*, trans. Albert J. Wehrle, Cambridge, MA: Harvard University Press.

Miles, Margaret R. (1989) *Carnal Knowing: Female nakedness and religious meaning in the Christian west*, Boston, MA: Beacon Press.

Morson, Gary Saul and Emerson, Caryl (eds) (1989) *Rethinking Bakhtin: Extensions and challenges*, Evanston, IL: Northwestern University Press.

Morson, Gary Saul and Emerson, Caryl (1990) *Mikhail Bakhtin: Creation of a prosaics*, Stanford, CA: Stanford University Press.

Olin, Margaret (1992) *Forms of Representation in Alois Riegl's Theory of Art*, University Park, PA: Pennsylvania State University Press.

Ouspensky, Petr (l922) *Tertium Organum: A key to the enigmas of the world*, trans. Nicholas Bessaraboff and Claude Bragdon, 2nd ed., New York: Alfred A. Knopf.

Pächt, Otto (1963) 'Art Historians and Art Critics – vi: Alois Riegl', *Burlington Magazine* 722 (May), pp. 188–93.

Pechey, Graham (2007) *Mikhail Bakhtin: The word in the world*, London and New York: Routledge.

Perlina, Nina (1984) 'Bakhtin and Buber: Problems of dialogic imagination', *Studies in Twentieth-Century Literature* 9/1, pp. 13–28.

Pissarro, Joachim (1990) *Monet's Cathedral: Rouen, 1892–1894*, New York: Alfred A. Knopf.

— (1997) *Monet and the Mediterranean*, New York: Rizzoli.

Plato (1966) *The Republic*, ed. and trans. I.A. Richards, Cambridge: Cambridge University Press.

— (1983) 'Ion', in *Two Comic Dialogues*, trans. Paul Woodruff, Indianapolis: Hackett.

Pumpiansky, L.V. (2001) 'Appendix: M.M. Bakhtin's Lectures and Comments of 1924–1925', in Susan M. Felch and Paul J. Contino (eds), *Bakhtin and Religion: A feeling for faith*, Evanston, IL: Northwestern University Press, pp. 193–237.

Richards, Mary Caroline (1969) *Centering in Pottery, Poetry, and the Person*, Middleton, CT: Wesleyan University Press.

— (1991) *Imagine Inventing Yellow*, Barrytown, NY: Station Hill Press.

— (1996) *Opening Our Moral Eye: Essays, talks, & poems embracing creativity and community*, Deborah J. Haynes (ed.), Hudson, NY: Lindisfarne Press.

Riegl, Alois (1985) *Late Roman Art Industry*, trans. Rolf Winkes, Rome: Giorgio Bretschneider Editore.

Roos, Jane Mayo (1996) *Early Impressionism and the French State*, New York: Cambridge University Press.

Ross, Andrew (1994) 'The New Smartness', in Gretchen Bender and Timothy Druckrey (eds), *Cultures on the Brink: Ideologies of technology*, Seattle, WA: Bay Press, pp. 329–41.

Rothenberg, Albert (1998) 'Creativity and Psychology', in Michael Kelly (ed.), *Encyclopedia of Aesthetics* vol. 1, New York: Oxford University Press, pp. 459–62.

Rothfuss, Joan, Walker Art Center website. www.walkerart.org/archive/8/9C430DB110DED6686167.htm (accessed 10 April 2012).

Rozanova, Olga (1988) 'The Bases of the New Creation and the Reasons Why It Is Misunderstood', in John Bowlt (ed.), *Russian Art of the Avant Garde: Theory and criticism*, rev. ed., New York: Thames and Hudson, pp. 102–10.

Schofield, M. (1978) 'Aristotle on the Imagination', in Gwilym Ellis Lane Lloyd and Geoffrey Ernest Richard Owen (eds), *Aristotle on Mind and the Senses*, Cambridge: Cambridge University Press, pp. 99–140.

Schopenhauer, Arthur (1851) 'On Thinking for Oneself', in *Parerga and Paralipomena: Short philosophical essays*, trans. E.F.J. Payne, Oxford: Oxford University Press, 2000, Available from http://ebooks.adelaide.edu.au/s/schopenhauer/arthur/lit/chapter5.html [15 May 2012].

Scott, Joan (1988) 'Deconstructing Equality-Versus-Difference: Or, the uses of poststructuralism and theory in feminism', *Feminist Studies* 14/1, pp. 32–50.

Sheeler, Jessie (2003) *Little Sparta: The garden of Ian Hamilton Finlay*, photographs by Andrew Lawson, London: Frances Lincoln.

Shepherd, David (ed.) (1998) *The Contexts of Bakhtin: Philosophy, authorship, aesthetics*, Amsterdam, Netherlands: Harwood Academic Publishers.

Shields, Carolyn M. (2007) *Bakhtin Primer*, New York: Peter Lang.

Shiff, Richard (1986) 'The End of Impressionism', in Charles S. Moffett (ed.), *The New Painting: Impressionism 1874–1886*, San Francisco: Fine Arts Museums of San Francisco, pp. 61–89.

Siegel, Jeanne (1985) 'After Sherrie Levine', *Arts Magazine* 59 (Summer), pp. 141–44.

Sims, Lowery and King-Hammond, Leslie (2010) *The Global Africa Project*, New York: Museum of Arts and Design.

Singerman, Howard (2012) *Art History, after Sherrie Levine*, Berkeley, CA: University of California Press.

Solovyov, Vladimir (1974) *A Solovyov Anthology*, arr. S.L. Frank, trans. Natalie Duddington, reprint ed., Westport, CT: Greenwood Press.

Sontag, Susan (2003) *Regarding the Pain of Others*, New York: Farrar, Straus and Giroux.

Spate, Virginia (1992) *Claude Monet: Life and work*, New York: Rizzoli.

Stafford, Barbara (1991) *Body Criticism: Imaging the unseen in enlightenment art and medicine*, Cambridge, MA: The MIT Press.

Sternberg, Robert (ed.) (1988) *The Nature of Creativity*, New York: Cambridge University Press.

Stigh, Daniela and Jackson, Zoë (2010) 'Marina Abramović: The artist speaks', Available from http://www.moma.org/explore/inside_out/2010/06/03/marina-Abramović-the-artist-speaks (accessed 29 January 2012).

Strong, Roy (2000) *The Artist and the Garden*, New Haven, CT: Yale University Press.

Stuckey, Charles (ed.) (1985) *Monet: A retrospective*, New York: Hugh Lauter Lenin.

Sturken, Marita and Cartwright, Lisa (2008) *Practices of Looking: An introduction to visual culture*, Oxford and New York: Oxford University Press.

Sussler, Betsy 'Cindy Sherman', *BOMB* 12 (Spring 1985), Available from http://bombsite.com/issues/12/articles/638 [7 April 2012].

Todorov, Tzvetan (1984) *Mikhail Bakhtin: The dialogical principle*, trans. Wlad Godzich, Minneapolis, MN: University of Minnesota Press.

Torrance, Ellis Paul (1962) *Guiding Creative Talent*, Englewood Cliffs, NJ: Prentice-Hall.

Tupitsyn, Victor (1996) 'Kabakov non ha disogno di medaglie' [Kabakov does not need medals], *D'Ars* 148, pp. 43–47.

Turkle, Sherry (1995) *Life on the Screen: Identity in the age of the internet*, New York: Simon and Schuster.

Visona, Monica B. et al. (2008) *A History of Art in Africa*, 2nd ed., Upper Saddle River, NJ: Pearson/Prentice Hall.

Voloshinov, V.N. (1986) *Marxism and the Philosophy of Language*, trans. L. Matejka and I.R. Titunik, Cambridge, MA: Harvard University Press.

— (1987) *Freudianism: A critical sketch*, trans. I.R. Titunik, Bloomington, IN: Indiana University Press.

Wallas, Graham (1926) *The Art of Thought*, New York: Harcourt-Brace.

White, Christopher and Buvelot, Quentin (eds) (1999) *Rembrandt by Himself*, London: National Gallery.

Woodward, Richard B. (2012) 'Roles of a Lifetime', *Wall Street Journal*, Available from http://online.wsj.com/article/SB10001424052970204653604577249771626916422.html [21 March 2012].

Zbinden, Karine (2006) *Bakhtin between East and West: Cross-cultural transmission*, London: Legenda.

Zerner, Henri (1976) 'Alois Riegl: Art, Value, and Historicism', *Daedalus* (Winter 1976), pp. 177–88.

Glossary

aesthetic event – With this concept Bakhtin introduced a potentially fruitful way of reconceiving the work of art. The term 'event' brings attention to the 'eventness' of art, to the fact that any artifact exists in a clear and invariable succession of temporal and spatial conditions involving both the artist and viewer. Such a concept challenges more static ways of conceiving the creator–object–viewer–context relationship. The nature of the aesthetic event is further elucidated with the idea of 'living-into'. When we encounter a work of art, we often project ourselves into the work. The concept of empathy, which Bakhtin so roundly criticised, names this process. We live ourselves into a work in order to feel its impact. But if our response as viewers or critics simply stops here, in the experience of empathy, we are effectively disempowered, since the ability to act in the world depends upon a moment of separation when we return to re-experience our own unique position. If visual art is ever to have social or political efficacy, the critic or viewer must practise this kind of living-into *and* separation that characterise the aesthetic event.

answerability – Bakhtin emphasised that we are not obligated by theoretical norms or values, what he called *theoretism*, but by real people in real historical situations. A genuine life and genuine art can only be realised in concrete responsibility or answerability. His early essay, 'Art and Answerability', is Bakhtin's initial attempt to articulate ideas that he would spend much of his life elaborating. Answerability is the name for individual responsibility and obligation that leads to action, for ourselves, of course, but also on behalf of others. By the late 1920s the general notion of answerability or responsibility was replaced by dialogue and the dialogic, both of which have stronger linguistic valence.

architectonics – A term derived from architecture. In Bakhtin's early essays it does not refer to a strict formal cognitive structure, but is instead

an activity that describes how relationships between self and other, self and object, self and world are structured. Bakhtin's written definition is vague and paradoxical, but in general it means the ordering of meaning and the integration of parts to form a whole, around a distinct person. As he would repeat many times, the human being is the organising centre in the actual world and in aesthetic vision.

carnival – A site or ritual where hierarchies and power inequities break down or are overturned. A 'pageant without a division into performers and spectators...The place for working out, in a concretely sensuous, half-real and half-play acted form, *a new mode of interrelationship between individuals*, counterposed to the all-powerful socio-hierarchical relationships of non-carnival life' (Bakhtin 1984a: 122–23).

chronotope – There is no experience outside of time (*chronos*) and space (*topos*), both of which always change. Subjectivity dictates that an artist create objects that are always constituted differently. The fact that all conditions of experience are determined by space and time, which are themselves variable, means that every artwork exists in a unique chronotope. Within any situation there may be many different chronotopes, values and beliefs; these derive from actual social relations. In examining diverse arts, it is useful to consider the chronotope of the work in relation to one's own chronotope.

dialogue – Dialogue and the dialogic are perhaps the most misunderstood of Bakhtin's concepts, not least because he invoked the terms in many contexts over years. Bakhtin used the concept of dialogue and the dialogic in at least three distinct ways (Morson and Emerson 1990: 130–31). First, dialogue refers to the fact that every utterance is by nature dialogic. Second, dialogue means utterances that are directed to someone in a unique situation, and thus dialogue can be either monologic or dialogic. Third, Bakhtin understood life itself as dialogue. We participate in such dialogues our entire lives, with our bodies and through the acts we undertake. Dialogue, therefore, is epistemological. Only through dialogue do we know ourselves, other persons and the world.

event (eventness, event of being) – For Bakhtin both life and art have the character of an event. As described by the German Neo-Kantian Wilhelm Windelband, an event implies time, where each moment or aspect of

experience is real and separate, and occurs in an inalterable series. In Bakhtin's early essays eventness is not an abstract system that can be applied to all cultures across time, but a very specific way in which the world can be perceived as an emerging event in each unique, particular and singular situation. Bakhtin differentiated between the 'event of being' and the 'aesthetic event'. In life 'the event of being is a phenomenological concept, for being presents itself to living consciousness as an event, and a living consciousness actively orients itself and lives in it as an event' (Bakhtin 1990: 188). This does not mean that there is just one singular unified event; rather, there are as many different worlds of the event as there are individual, uniquely responsible subjects. Bakhtin's use of the concept emphasises the transitional and transitory 'eventness' of life, movements from past and present to future that characterise our subjectivity, and through which we become unique. Within life, only death consummates or brings to an end the ongoing event of life. This sense of the event *of* life is contrasted with the idea of events *in* life.

great time and small time – Great time is the infinite and unfinalised dialogue in which no meaning dies. It is useful for understanding cultural artifacts and even entire cultures. With this term Bakhtin wanted to bring attention to the way dialogue with art never ends. He asserted that a 'text lives only by coming into contact with another text (with context)' (1986: 162). Great time refers to the way works of art become part of history and the great cycles of the cosmos. Small time is a way of designating the present day, the recent past, and the foreseeable or desired future. These categories of time are based not on a grand historical metanarrative, but on a nuanced appreciation of outsideness and the chronotope.

heteroglossia – Developed in Bakhtin's writings of the 1930s, this term refers to the mingling of different languages, cultures and classes, where each individual language expresses a specific way of conceptualising the world. In practice, heteroglossia is evident in the presence of many voices in a discourse, text or work of art, each of which expresses a unique point of view.

loophole – Because one's subjectivity can never be contained or encompassed by the outer world, there is always a loophole through which to escape. The other person may be associated with the world, but the self is oriented by a nonspatial inner centre that always exceeds

the world. The idea of the loophole has several frames of reference: as a metalinguistic form, an ideology and a view of the world (Morson and Emerson 1990: 67–71, 159–61).

monologism – The opposite of polyphony, monologism means that dialogue becomes empty and lifeless, dominated by a single authoritative voice. Bakhtin argued that modern thought, including literature and art, has been dominated by a narrow dialectical monologism and by monologic conceptions of truth. Ideology was a particular form of monologic thinking, subject to the same problems and limitations as religious monotheism.

outsideness – Bakhtin used the concept of outsideness to criticise and balance the notions of aesthetic empathy and identification, understood from a Neo-Kantian perspective. For Bakhtin aesthetic and moral activity only begins after empathy, which he interpreted as a kind of living-oneself-into the experience of another person. Only with the return into the self, and with clear boundaries between the self and other, do we begin to form and consummate the experience derived from projecting the self into another's position. Bakhtin viewed outsideness as crucial for moral action on behalf of others.

polyphony – To be truly dialogic or polyphonic, verbal communication and social interaction must be characterised by paradox and differing points of view. The term refers to the interaction of multiple distinct voices that do not merge. Polyphony can also be considered a theory of creativity in itself.

prosaics – Prosaics refers first to the comprehensive theory of literature that Bakhtin developed, a theory that privileges prose and the novel. But second, prosaics is a way of thinking that foregrounds the everyday and ordinary. The term was given prominence by Gary Saul Morson and Caryl Emerson (1990).

theoretism – Bakhtin's name for his aversion to all unified and orderly structures or systems. His critique of theoretism was neither sustained nor systematic. Bakhtin's view of theoretism may be best understood as a multistep process and way of thinking. First, it abstracts what can be generalised from specific human actions. Second, it considers this abstraction as whole and complete; then, third, develops a set of rules

from the abstraction. Fourth, norms are then derived from this set of rules. Theories and theoretism cannot provide effective criteria for shaping one's active life in the world.

unfinalisability – A core concept in all of Bakhtin's writing, unfinalisability results from the fact that we are finite human beings and have finite knowledge. What we apprehend are constructions, and inevitably conflicts arise over these constructions. Therefore no one person or one group can contain the truth because we simply cannot see everything that is. Unfinalisability can help us to articulate complex answers to questions about particular works of art. When is a work finished? Can it ever be truly finished? When is a critical perspective or audience reception complete? In Bakhtin's formulation, the sense of freedom and openness that is encompassed by the idea of unfinalisability applies not only to works of literature and art, but is also an intrinsic condition of our daily lives. Unfinalisability therefore has at least two distinct levels: the ways we need others in order to finalise the self; and the ultimate unfinalisability of all things, events and persons. Art and life are ultimately open-ended.

utterance – A finished and completed thought, which may be a word, phrase or sentences. Although the word refers to verbal language, a work of art may also be an utterance. An utterance can never be abstract but must occur between two persons: speaker and listener, creator and audience, artist and viewer. It is always directed at somebody in a living, concrete, unrepeatable set of circumstances.

Index